Classroom
Record
Keeping
Made Simple

Classroom Record Keeping

Made Simple

Tips for Time-Strapped Teachers

Diane Mierzwik

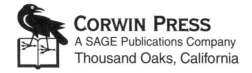
CORWIN PRESS
A SAGE Publications Company
Thousand Oaks, California

For information:

Corwin Press
A Sage Publications Company
2455 Teller Road
Thousand Oaks, California 91320
www.corwinpress.com

Sage Publications Ltd.
1 Oliver's Yard
55 City Road
London EC1Y 1SP
United Kingdom

Sage Publications India Pvt. Ltd.
B-42, Panchsheel Enclave
Post Box 4109
New Delhi 110 017 India

Printed in the United States of America

Library of Congress Cataloging-in-Publication Data

Mierzwik, Diane.
Classroom record keeping made simple: Tips for time-strapped teachers/Diane Mierzwik.
 p. cm.
Includes bibliographical references and index.
ISBN 1-4129-1456-6 (cloth)—ISBN 1-4129-1457-4 (pbk.)
 1. Student records—Handbooks, manuals, etc. 2. School reports—Handbooks, manuals, etc. 3. Teachers—Handbooks, manuals, etc. I. Title.
LB2845.7.M54 2005 2005005357

This book is printed on acid-free paper.

05 06 07 08 09 10 9 8 7 6 5 4 3 2 1

Acquisitions Editor:	Rachel Livsey
Editorial Assistant:	Phyllis Cappello
Production Editor:	Beth A. Bernstein
Copy Editor:	Kristin Bergstad
Typesetter:	C&M Digitals (P) Ltd.
Proofreader:	Liann Lech
Indexer:	Teri Greenberg
Cover Designer:	Rose Storey

Contents

Preface

David had failed class, actually several classes, and his parents were livid, but not because David hadn't received good instructional time or hadn't been exposed to the grade-level curriculum. His parents were upset with the teachers for not notifying them of David's impending failure.

Many teachers in the meeting pointed out that the parents had been notified via the mandatory progress report, which conveniently never made it into the parents' possession. One teacher, on the other hand, produced a phone log indicating the times he had contacted the parents because of David's missing work, provided the parents with several of David's assignments with their signatures on them indicating notification of a failing grade, and a detention slip signed by the mother—the detention was for failure to complete a major project.

At first, the parents wanted to argue with the teacher, implying that he hadn't done enough to notify them, but in the face of all the records, they admitted that they were disappointed in David and their trust in him had been broken.

Although 25 percent of all secondary schools are currently involved in lawsuits (see www.Edweek.org), the likelihood of you, as a teacher, being involved in a lawsuit is lower. Unfortunately, the chances of your classroom practices being called into question are much higher.

A colleague of mine was absent for the day, and the substitute teacher showed a video that was inappropriate. When Samson returned from his illness, he was bombarded by angry parents' phone calls about the previous day's "lesson plans." Luckily, Samson had written clear lesson plans for the substitute teacher that did not include watching a video. He had a record of his intentions for his students regarding the curriculum to be covered in his absence. Instead of wasting time defending his practices in the classroom, Samson quickly responded to the angry parents with a copy of the lesson plan left for the substitute teacher, which reassured parents of Samson's professionalism. The substitute teacher was never called to work within the school district again, and Samson had parental support for the remainder of the year.

WHY KEEP MORE RECORDS?

Most teachers already spend a hefty chunk of time each day keeping records: recording grades, documenting classroom management, attending

meetings, and keeping notes. If you are already spending so much of your work week documenting and reporting on your actions with students, how could you possibly keep more records without jeopardizing your instructional time with students, your planning time for students, or your private time with family?

Keeping more records does not require you to spend more time keeping records. It requires you to manage the paper trail already produced in your daily teaching to justify classroom decisions, protect yourself against unwarranted attacks, and provide your school and/or school district with records for improving instruction for future curriculum decisions. You will find that managing these records saves you time in the course of your day, your week, your semester, your school year, and your teaching career.

GOALS OF THE BOOK

As teachers, we deal with stacks and stacks of paper every day. How do we manage those and more papers without a full-time secretary to help us? The goal of this book is to provide you with tools and techniques to use the papers already generated in your day, fine-tune paperwork for use as records, and create time-saving records to alleviate some of the time-consuming practices you may be using.

In our daily teaching, papers are naturally generated that can be used for record keeping. Papers like messages from the front office, parent letters generated from the office, and school meeting agendas can all be filed for future reference. Your lesson plans or planning book and other papers you create in your day-to-day teaching can be used to inform your decisions. With an understanding of how these papers can be filed for later use, you will be able to begin keeping records without adding any time to your teaching day.

Finally, creating some record-keeping practices will actually save you time in the course of your teaching year and your teaching career. Using document records such as phone logs, tutoring sign-ins, or seating charts will help you to keep accurate records of your parent contacts, your time with students, and behavioral management in class. These records require very little of your time up front and save you time in the long run, especially if your practices are ever called into question.

The goal of the book is to help you keep records to inform your decisions, plot your successes, and save time.

WHAT KIND OF RECORD KEEPER ARE YOU?

Each year at tax time, I sit down and gather all my records. Now, my records are more like a paper trail, literally. I'm the Hansel and Gretel of keeping records, collecting rocks to drop along my path to find my way home so I don't end up in the IRS's oven. I don't sit down once a month, as is suggested in most books, to log in my expenditures and record my

receipts. I don't use a computer program or any other electronic form of keeping records. Instead, I have a drawer where I throw all my receipts for the year or, if I'm really organized, an accordion file to throw these papers in until a week before my tax appointment.

A week before my tax appointment, I empty out my drawer of papers and begin stacking them into piles: rentals, school, home, child care, et cetera. Inevitably, I keep papers that I don't need and that end up in the trash, but rarely is there something I need that I didn't keep. Once I have stacks, I begin organizing them and calculating my numbers to give to Big Al, my taxman.

I know my system appears to be unsystematic. How do I keep track of whether or not I'm staying within my budget? How do I know if I'm going to come out ahead or behind at the end of the year for taxes? My answer: It's all in my head. I'm intuitively a good money manager. I don't need to sit down every month to keep track of my finances. Would I do a better job of managing my money if I did? That remains to be seen. Once my child is grown and I have more time on my hands, I may try another method, but for now, given my time commitments to my family, career, and hobbies, this system is working for me.

This is how I keep records at school, too. I have a file folder for all discipline records, a file folder for all parent contacts, and files for student work. When I have a meeting or need to justify a referral for special programs, I sit down with my folders and pull out the papers I need to accomplish my goal. As with my taxes, there are many papers in these folders that I never use in the course of the year, and at the end of the year, I throw those papers away. On the other hand, I always have all the papers necessary when I need to document my actions with a student or with curriculum.

On the other hand, I have friends who track every dime they spend each week. They pay all their bills online and use an electronic money manager to record their income, their expenditures for living, and their spending habits. When it's tax time, they push a button on their computer, and all their records are done for them. Of course, they still have their paper trail, but they don't have to dig through it all to prepare for taxes. They have been organizing their records a little at a time each month.

Likewise, there are teachers who keep a file on every student and daily records of actions taken in the classroom. Some teachers keep this record as a journal; others create forms to fill out at the end of any significant interaction. Still others use their computer to keep these records.

These are examples of extreme types of record keepers. Each of us falls somewhere on this continuum. It is important for you to find the type of record keeping with which you are most comfortable and then use that to your advantage. The book will provide you with the wide spectrum of how to keep records, from the Hansel-and-Gretel method to the manager expert. It is up to you to try the different methods to discover which works best for you. No matter what type of record keeper you are, this book will help you to keep accurate records, manage them better, and be able to present them in a convincing manner when necessary.

OVERVIEW OF CONTENTS

Chapter 1 shows you how to use papers and plans you are already generating as records of your teaching decisions, curriculum planning, instructional strategies, and classroom decisions.

Chapter 2 reviews methods of keeping records for student assessments. It examines the use of portfolios, grades, assignments, and numerous other assessment tools and how these need to be recorded for information regarding student achievement and growth, for information to inform your decisions regarding instructional practices and classroom management, and for presentation to other stakeholders in your educational setting.

Chapter 3 provides you with methods of keeping track of your parent contacts from phone calls home to sending home grades. Chapter 4 helps you to keep records regarding your classroom management to provide you with information about a student's time on task, help you document the need for special programs, and provide evidence of your intervention with students who have behavioral issues.

Chapter 5 provides you with techniques to keep records detailing the accommodations you make for students with special needs. It also provides you with templates for creating records in this especially litigious area of teaching. Chapter 6 prepares you for using your records in meetings with parents, administrators, or outside agencies.

Finally, the book provides an appendix where you will find all the templates used in the book, along with suggested books for more in-depth looks at record keeping for specific areas.

ACKNOWLEDGMENTS

I would like to thank the following for their input during the inception and writing of this book.

Lynn Anderson
School Psychologist
San Bernardino City Unified School District
San Bernardino, CA

Bill Mierzwik
Head Baseball Coach
San Bernardino Valley College
San Bernardino, CA

The contributions of the following reviewers are gratefully acknowledged:

Mike Greenwood
Staff Developer
Windsor Public Schools
Windsor, CT

J. "Kimo" Spray
Principal
Benjamin Rush Elementary
Redmond, WA

Sharon L. Jeffery
National Board Certified Teacher
Adolescent Science
Plymouth Public Schools
Plymouth, MA

Charles F. Adamchik, Jr.
Director of Curriculum
Learning Sciences International
Blairsville, PA 15717

About the Author

 Diane Mierzwik currently teaches seventh- and eighth-grade English at Parkview Middle School for the Yucaipa-Calimesa Joint Unified School District in California. In her 16 years of teaching, she has had experience with 1st through 12th graders. She has been Gifted And Talented Education coordinator, Leadership team member, Department Head, and a mentor teacher; completed the Inland Empire Writing Project; and served as a Language Arts consultant for the California Language Arts Project. She is also the author of *Quick and Easy Ways to Connect With Students and Their Parents*, available from Corwin Press, and *Wishes in the Field*, a middle-grade historical fiction novel.

Instructional Records

Lesson plans are the foundation of every teacher training course every teacher has ever taken. When I was in school, we had to produce Madeline Hunter's seven-part lesson plans with an objective; the standard; the anticipatory set; teaching (input, modeling, checking for understanding); guided practice; closure; and independent practice. I wrote these lesson plans until I dreamed about them controlling not only my student-teaching classroom, but my finances, my housework, my driving, even my love life. At the time, I thought it was all a bit much.

When I finally got a full-time teaching job, I quit writing lesson plans as soon as possible. I had a principal who didn't request plans from new teachers, so I wrote an occasional plan for my university supervisor, and the rest of the time, I flew by the seat of my pants, trying to decide what to do with my students on my way to work each morning. I told myself that I was an organic teacher, not able to plan because I wouldn't know what my students needed from me until we had gotten through the present day. I was a student-directed teacher, letting my students' needs determine my lesson plans. There was no way I could plan days in advance because I had no way of knowing where my students' needs would direct my curriculum.

I soon learned that the course syllabus is my road map. With it, I have an orientation for where I am, where I am going, and what my major stops are along the way.

Lesson plans are my street map. They help me know where and when to turn. Today I write lesson plans to inform my teaching; to help me meet the ever-changing needs of my students without losing sight of our destination; and as records to justify and inform my decisions with the curriculum, with my students, and for my site organization: department, administrator, parents.

Assignment records, worksheets used, and directions given are the specific markers that make sure we are all on the right course. Standards alignments are the reward when we reach our destination and see how far we've come. Proper substitute plans ensure that even when we may be indisposed, the rest of the party heads in the right direction.

I've found that investing time at the beginning of each teaching unit actually saves me time in the long run, not to mention stress. It's like driving somewhere new. Someone has provided you with an address, a destination. Someone may have even given you verbal directions that you wrote out diligently: turn left at the stop light, right at the third house, and so on. For some people, this is enough information. For people who get confused easily, like myself, a map, a visual representation of where I'm going, helps. I have learned that the time invested in looking up the map and familiarizing myself with my destination makes my trip less stressful and my driving time more productive.

When you invest time in planning your teaching unit before you begin, you will begin each teaching day with a destination in mind, you will know how you are going to get to your destination, and if someone in the backseat has to take a potty break, you will be able to adjust easily to the distraction. You might even lead others in the caravan, who knows.

The records you must keep as a teacher include a course syllabus, lesson plans, assignment records, worksheets used, directions given, standards alignment, and substitute plans. These documents will

- Improve the quality of your instruction
- Provide students with clear objectives and expectations
- Clarify for parents what is happening in the class
- Provide your administrator with documents for evaluations and reports to the district office
- Document for your district your classroom practices

COURSE SYLLABUS

A course syllabus or unit overview is the first ingredient in a successful teaching year. It is also a necessary document if your teaching practices are ever called into question.

With state standards becoming commonplace and district curriculum maps becoming increasingly accepted as the norm, many districts

will already have done this and will provide it to you (Thompson, 2002). Most school districts are recognizing the benefits of ensuring that every student receives similar curriculum in each grade level across schools in the same district. If a syllabus, curriculum map, or unit overview is not provided for you, and you are a new teacher, asking for help from a veteran teacher will alleviate much of the stress of trying to create one.

It is important to have your course syllabus written down and handy for future reference. Not only will it guide your daily lesson plans, but it will be available for you the next teaching year for adjustments and improvements. Having a written document allows you to adjust, improve, and rely on what you are already familiar with.

Once you have collected your textbooks for the course, obtained the state standards for your grade level and course, and reviewed the curriculum covered the previous year, it is time to begin your planning. First, you will need to determine what you will teach, when you will teach it, how deep into the curriculum you will go, and how many weeks you will devote to each topic (Wyatt & White, 2002). Many of these decisions will be made for you based on the textbooks and state standards. Some teachers will even be tempted to skip this document, relying on a printout of the state standards and the table of contents of the textbook, but that may lead to covering information out of sequence, over and over in different formats, or simply prevent you from using time optimally.

If you are ever questioned about the scope and sequence of your instruction and all you can produce are the state standards and the textbook, your credibility may be damaged. Also, handing out a course syllabus specific to your class to parents and students allows them to see the objectives, the journey, and the destination of your class, which gives the students a sense of control over how well they can master the content of your class (Ryan, 2003), helping you to ensure the success of all students. A course syllabus gives you credibility and a sense of control over your curriculum.

When planning a syllabus, three documents need to be in front of you: a calendar (preferably one you can write on), the state or district standards, and the textbook(s) for the course. Working in collaboration with other teachers at your school site and/or within your district is the best scenario. Most districts provide teachers with planning days for this before each semester, and using this time to work with others will ensure that your syllabus is on track with what others are doing in your district. Whether you work alone or with others, you will want to create a rough draft syllabus that can be adjusted as you work on it.

Once you have all the information recorded, you have created a record to provide your administrator or department, justify your curricular decisions, familiarize your students and their parents with the course expectations, and inform your lesson planning. A syllabus planner might look like the sample syllabus planner on the next page.

Sample Format for Syllabus

Key standards to be covered:

* _____

* _____

* _____

Standards to be reviewed:

* _____

* _____

* _____

Textbook(s): _____

Unit title: _____

Dates: _____

Objectives (Students will . . .):

1. _____

2. _____

3. _____

4. _____

5. _____

Assessments: _____

Projects: _____

Worksheets: _____

Key readings, outside readings: _____

After you have used the document for lesson planning, it will be important to keep it handy for future reference.

Sample Format for Syllabus – GRADE FOUR HISTORY/SOCIAL SCIENCES

Key standards to be covered:

*4.1. Students demonstrate an understanding of the physical and human geographic features that define places and regions in California

*4.1.1. Explain and use the coordinate grid system of latitude and longitude to determine absolute locations of places in California and on Earth

*4.1.4. Identify the locations of the Pacific Ocean, rivers, valleys, and mountain passes and explain their effects on the growth of towns

Standards to be reviewed:

*3.1. Students describe the physical and human geography and use maps, tables, graphs, photographs, and charts to organize information about people, places, and environments in a spatial context

*3.1.1. Identify geographical features in their local region

*3.1.2. Trace the ways in which people have used the resources of the local region and modified the physical environment

Textbook(s): Harcourt Brace: Social Studies

Unit title: Missions in California

Dates: September 24-October 29

Objectives (Students will . . .)

1. Locate missions on map

2. Describe how far from or close missions are to geographical locations such as the ocean

3. Write a paragraph describing a specific mission

4. Make a chart of available resources for a specific mission

5. _____

Assessments: Oral presentation of chart

Rubric used for paragraph

Projects: Chart of resources for missions

Build a model of a mission

Worksheets: "Missions in California"

Key readings, outside readings: none yet

LESSON PLANS

One of the most important records you will keep as a teacher is your daily lesson plan book. "Careful lesson planning is mandatory if effective teaching and learning are to follow" (Johnson, Dupuis, Musial, Hall, & Gollnick, 2002 p. 439). Most schools provide you with a book in which you can keep your lessons, but with technology, many will find it easier to keep plans on the computer. However you decide to record your daily lesson plans, it is important to have them in a format that is legible, consistent, and organized.

Once you have decided how and where you plan to keep records of your daily lesson plans, you should come up with a format that you are comfortable with. "There is no one right format for these plans. Develop a format that works for you. It should be simple, yet complete" (Partin, 1995 p. 62). New teachers usually write lesson plans that are very detailed. This is important when you are beginning your career as a teacher because you want to ensure that you have covered all the components necessary for a successful lesson. Relying on the method taught in your teacher education courses is always a good idea.

Sample Lesson Plan

Date: _____ Course: _____

Unit of study: _____

Set or sponge activity: _____

Review of homework: _____

Standard: _____

Objective: _____

Instruction: _____

Pages in textbook: _____

Guided practice: _____

Independent practice or homework: _____

Closure: _____

Assessment to be used at end of unit: _____

As teachers become more experienced, their lesson plans may become more truncated, making perfect sense to them but looking like just a bunch of notes to someone else. As stated earlier, the important component of this record is that it is consistent. Once you have adopted a format, try to stick with that format for the entire year.

Standard: _____

Objective: _____

Sponge: _____

Instruction/Pages of textbook: _____

Activity: _____

Homework: _____

After you have decided on a format, there are some key elements that should be included in every lesson: standards and objectives, necessary materials or equipment, anticipatory set, explanation or teacher input, student activities, alternative activities, closure, homework, and assessments (Burke, 2002). Including all of this information in your lessons represents the thought that has gone into your instruction.

Lesson plans as records are important to you professionally. "The lesson is where education takes place" (Slavin, 2003 p. 221). If you fail to keep accurate records of your daily lessons, you leave yourself open to questions about your effectiveness as a teacher, your goals for your students, your commitment as a professional, your ability to build student knowledge, and your organization as a player in your larger school setting.

Every teacher has heard the question, "Why do we need to learn this stuff?" I heard it most often last year during my poetry unit. The students had the course syllabus, which showed the state standards the unit was addressing, and they were familiar with the end-of-unit assessment they were required by the district to complete. Still, "When will we ever use this again?"

Faced with these questions, I reviewed my lesson plans. It was clear that I hadn't made the assignments and information pertinent enough to the lives of my students or I wouldn't have been plagued by these questions. Course syllabi and quarter assessments are motivation enough for some students, but others want to know why the course syllabi and quarter assessments require they become familiar with this information. It was

true, only a select few would ever be moved to write poetry for a living or a hobby, so why must they all learn the information? After reviewing my lesson plans, I did some adjustments and spent a day looking at how much money is spent in America on greeting cards. Then we wrote our own greeting cards using metaphors, similes, personification, rhymes, and rhythms. Suddenly, students saw how learning about poetry applied to their lives.

In my lesson plans, I knew my destination and so did my students. Convincing them to take the trip with me meant that I had to make a stop along the way that they enjoyed. Having a plan, knowing my map, gave me the flexibility to adjust to the needs of my students. Lesson plans have not prevented me from basing my instruction on my students' needs. Actually, they help me to meet their needs more effectively.

ASSIGNMENT RECORDS

The next set of documents that will grow naturally out of your daily activities with your students is your assignment records. Assignments will be listed in your daily lesson plans, but it is important to have access to a document separate from your daily lesson plan book that lists all assignments completed in your class (see sample Assignment Sheet on p. 9).

Many teachers write their daily assignments on the white board for students to copy. I have visited many classrooms in which the teacher not only had the assignments written on the board, but also had a calendar posted in the back of the classroom that had all the assignments listed. Such calendars are a great help for students to learn the importance of time-management and for students who have been absent, especially if the assignment has been erased from the board. Finally, many teachers print a weekly or monthly list of assignments due in the class for students to refer to during the course of a unit. Some teachers also keep track of their assignments using a computer grading program such as *Grade Machine* or *Making the Grade*. This option allows teachers to print out a list of in-class assignments, homework assignments, assessments, and projects.

However you decide to keep track of the assignments in your class, you must be prepared to provide the list on demand. I have worked with many teachers who write the daily assignments on the board with the expectation that every student will copy the assignments. When a child fails to do this and a parent calls, it is not enough to explain that the expectation is that every child should copy the assignments from the board. Once this expectation has been explained, it is then pertinent to provide the parent or student with a copy of the assignments, or at least an opportunity to copy the assignments again (from the calendar posted in class). Failing to do so leaves you open to criticism for your lack of reciprocity in ensuring every student's success.

Assignment Sheet

<u>Monday:</u> Textbook or materials needed: Pages:

Title of assignment:

Directions:

<u>Tuesday:</u> Textbook or materials needed: Pages:

Title of assignment:

Directions:

<u>Wednesday:</u> Textbook or materials needed: Pages:

Title of assignment:

Directions:

<u>Thursday:</u> Textbook or materials needed: Pages:

Title of assignment:

Directions:

<u>Friday:</u> Textbook or materials needed: Pages:

Title of assignment:

Directions:

A completed assignment record for an entire month may look like this:

Month of May Assignments

May 3–7

 Read pages 45–57 of textbook

 Answer questions on pages 58–59

 Complete worksheets provided in class

 Provide resources for unit project

May 10–14

 Read pages 61–68 of textbook

 Answer questions on pages 69–70

 Complete worksheets provided in class

 Provide outline or plan for unit project

May 17–21

 Read handout chapter provided by teacher

 Write summary of chapter, including key points

 Provide a list of materials needed to complete unit project

 Organize lecture notes for notebook

May 24–28

 Review for end-of-unit assessment to be taken on Friday

 Turn in unit notebook by Wednesday

 Turn in unit project rough draft

 Sign up for project presentations for next week

Once you have generated this list, you will want to keep several copies on hand for parent or student questions and file several copies for your records.

WORKSHEETS

Providing opportunities for students to successfully practice a skill taught in class and providing pencil-and-paper time that prepares students for pencil-and-paper assessments is an integral part of your planning. Worksheets—for lack of a better term—provide these opportunities.

Busy work is not the same as paper-and-pencil work that allows practice time to reinforce and extend concepts learned in class. Many instructional strategies that engage the brain can be done with a published or teacher-generated run-off such as: drawing/art, graphic organizers, semantic maps, word webs, metaphors, analogies and similes, mnemonic devices [or guided] writing (Tate, 2003). It is important that classroom time not be filled with busywork, but with meaningful instructional time. When you come across a worksheet that yields the desired results, you will want to keep track of it for future use.

Keeping track of which worksheets you have used in your classroom, whether they are teacher-generated or taken from a textbook, is vital for recording opportunities provided to students for skills practice.

With a course syllabus, lesson plans, and an assignment sheet, your students have a destination, a vehicle for making the trip, and a map to follow. Worksheets are like the street signs or the landmarks to help students plot the success of their trip. Keeping track of these documents by placing a copy of each worksheet, the date each worksheet was used, and a key for the completion for each worksheet will help make your teaching day more manageable.

I've been in meetings with students and their parents in which I was accused of losing papers. If you teach for very long, you too will eventually be accused of this. It happens to the best of us.

Sitting with a student and parents who are sure you have been irresponsible with a student's papers can be unnerving. Being prepared with your lesson book, a list of assignments, and copies of the student's other work takes the conversation away from whether or not you lost a paper and focuses the conversation on keeping the expectations for the class clear for all involved.

Often, when the parents see how prepared you are for the meeting with all of your records, and when the student actually sees a copy of the work in question, it turns out to be a big misunderstanding and everyone leaves feeling like the problem can be solved. So many times, once students see a copy of the assignment, they recognize it and it's in their folder ungraded because they didn't realize the assignment had ever been collected.

Keeping a file of all worksheets used in your classroom helps to prevent misunderstandings about lost work, helps to keep your curriculum focused on new information and the review and practice of skills, and informs your decision making for future lesson planning.

GENERATED DIRECTIONS FOR ASSIGNMENTS/PROJECTS

As a teacher, there will be many times when you will look at the unit to be presented and your daily lesson plans and want to create or modify a project to reach all learners. After all, you know in order to reach all of your students, not only will you need to rely on the materials and assignments provided to you in the textbook, but you will want to use many teaching methods for effective instruction (Jonson, 2002). Thus, you will be responsible for creating directions or worksheets to meet the needs of your project.

I remember when I began teaching elementary physical education. I had a class of first graders out on the blacktop that I was trying to organize for a game, and lining them up seemed like a good idea.

"Form one line," I announced confidently. My class of five- and six-year-olds milled around chaotically. How hard was it to form one line? I announced my directions several times until my lead teacher, Scott Kirby, wandered over and announced, "Everyone, I need your toes on this line facing me." Within seconds, the first graders were in one line, facing me, ready for the game.

"Form one line" meant several things to my group. Some students were trying to get behind the person they thought was the head of the line. Others were trying to stand side-by-side, but they were all unsure of which way to face. Still others were waiting patiently for the directions to be made clearer or for someone else to physically move them to their spot.

I learned a valuable lesson that day. Clear directions are pertinent to the success of my students.

When you plan a project or create your own worksheet, several things need to be included. Obviously, clear, step-by-step instructions are vital. A clearly posted due date is important so there are no misunderstandings about when the project is to be turned in. Finally, expectations for a successful project will make completing the project easier to accomplish for your students.

Each of these elements documents the care you as the teacher have taken to prepare students to be successful with the project. With these elements documented, there should be no questions, debates, arguments, or disputes about the project or worksheet.

Other elements you may want to include are the standard the project or worksheet addresses, the materials needed to complete the project or worksheet, and the grading rubric or checklist for assignment completion to be used to assess the project or worksheet.

Letter to the Author Book Report

For your first book report, you will be composing a letter to the author of the book you read. You will write the letter in a business style format. You will be required to introduce yourself to the author, explain why you chose his or her book to read, and describe your favorite part of the book. Yes, the letters will be sent.

Letter to the Author Book Report

Due: Friday, October 14

Date, salutation, closing (10 points) _____

Your address (10 points) _____

Author's name and address (10 points) _____

Paragraph introducing yourself (15 points) _____

Paragraph explaining why you read the book
you chose (15 points) _____

Paragraph describing your favorite part (15 points) _____

Pride in presentation: ink, neatness (10 points) _____

Mechanics (10 points) _____

TOTAL: _____

If there is any question as to a grade a student receives on a project or worksheet you have created, this clear documentation will resolve all issues by delineating expectations for students. It is important that all

students receive a copy of these instructions and that you keep several copies handy for questions you may receive from a parent and a copy to file for future reference. If the project is successful, you will want to use it again, or make adjustments for the following years as you gain more experience with the implementation of your creative ideas.

Planning for your directions requires several components:

Directions for Project

Objective: What is to be accomplished

Materials:

Method: Steps to accomplishment

 1.

 2.

 3. etc.

Special considerations:

Due date:

Filling in this information whenever you generate directions will help clarify the project for yourself and for your students.

MATCHING ASSIGNMENTS AND ASSESSMENTS TO STANDARDS

An important movement in public education today is the implementation of national and state standards. As the pressure grows for teachers to align their curriculum with the standards, it is important for you as a teacher to begin the process for your curriculum.

Many districts or departments are already in the process of aligning their curriculum, and so for many teachers, much of this work will have been done. The department in my district, for example, meets over the summer and aligns assignments, assessments, and readings from the district-adopted textbooks with the state standards.

If you are new to the district, check with your department chair to see if there isn't already a document that looks similar to this one. If not, don't despair. There is an easy way to begin to record how your curriculum meets the standards.

QTR	Standard(s) Blueprint	Key Words and Concepts	Assessment	Topics/Best Practices	Resources
	Quarter Standards for Eighth-Grade English				
1	Reading/Vocab Word analysis 1.0 Vocabulary and concept development 1.1 and 1.3	Idioms, analogies, metaphors, similes Definition and restatement and context clues	Lesson 1-6 More Abravocabra	Word Wall, Conversations, Vocabulary games (pp. 11-21), sentences	More Abravocabra Lessons 1-6
1	Reading **Vocabulary and Concept Development 1.1 Literary Response and Analysis 3.1 and 3.6**	Metaphor Simile Personification Symbolism Ballad Sonnet Lyric Couplet Ode	Teacher-selected quizzes Reading comprehension Assessment: "Oh Captain, My Captain" "Mother to Son" "Lesson of the Moth"	Poetry Poster Picture Poetry writing Compare and contrast simile poem Ode to a personal item	The Language of Literature "Willow and Gingko" "Macavity the Mystery Cat" "Lord Randall" "Paul Revere's Ride" "The Raven" Others to be selected by teacher
1	Writing **Writing Strategies 1.0, 1.1 Writing Applications 2.2**	Six Traits: Ideas Organization Conventions Interpretation Analytical response Inference	Six Traits First Quarter Writing Assessment	Practice essay with poem response	Analyzing a poem
1	Listening and Speaking **Speaking Applications 2.2**	Insightful interpretation Text-to-self connections		Poem and prose comparison	"Boats in a Fog" "Fog" "Winter's Fog"
1	Written and Oral English Language Conventions **Written and Oral Language Conventions 1.1 and 1.5**	Sentence and its parts Prepositions Capitalization Punctuation Verbs Diagramming	Standards plus grammar assessment	Diagramming sentences *Basic Firsts: Diagramming sentences* book A & B	Language Network

The first thing you will want to do is download a copy of the standards from your state and print them out. Once you have done this, and as you progress through the year, simply note on the document which assignments you give and where they fit into the standards. At the end of the school year, you will have created a working document for how your curriculum matches your standards.

The next step is to inform students and their parents of how the curriculum aligns with the standards. There is a big push for all stakeholders to have all the information about standards and curriculum. Providing students and their parents with a copy of this document assures everyone that you are providing the quality education to which all children are entitled.

SUBSTITUTE PLANS

The final document that must be created in the course of your school year is a substitute plan. None of us likes to be absent from school. Being absent requires us to write clear lesson plans for someone else to follow, gather and organize all the necessary materials for the lesson plan to be implemented, provide records for your substitute teacher to guarantee a smooth procedural day, and trust fate with all of your well-laid plans. Then we spend the entire day we are absent worrying that Luis is going to be off-task because we are not there to provide close physical proximity to reassure him of his ability, that Stephanie is going to forget to turn in her work because she usually must be reminded, or that Danny will ask so many questions about the lesson that the rest of the class will never be able to complete it. We spend the day imagining our return to class the next day to discover the materials in disarray, a stack of papers higher than we expected, and students bombarding us with how the substitute messed everything up. It is so much easier just to go to school.

But there will be those times that it is necessary for you to be absent, and it is vital that learning continues in your absence. A well-written substitute plan not only makes the day easier for the substitute teacher, but ensures that students will continue with their activities and learning without your presence.

If you are keeping a daily lesson book and have to be absent, it will be easy to simply use the scheduled lesson for your substitute plans. You may want to make some adjustments based on classroom management or availability of materials. It is easier for the substitute teacher to manage seatwork and books and paper, but if you have confidence in your substitute teacher, then little needs to be done to the lesson plan you have already written.

Substitute Teacher Plans

Introduction: (Logistics of the classroom)

Daily schedule:

Materials:

Teacher's role in lesson:

Student's role in lesson:

Closure:

Listing times needed to complete each part of the lesson may be helpful for the substitute teacher for pacing of the lesson. Also, setting out materials the substitute will need ensures that class time will not be wasted on searching for materials. Other things to leave for your substitute teacher are a daily schedule of activities, attendance forms and procedures, hall passes and procedures, seating charts, and classroom rules and consequences (Kottler, Kottler, & Kottler, 2004).

Sample Substitute Lesson Plans

Welcome to Room 29

English 7/8

October 1, 2003

I am out today due to illness. Seating charts are on the clipboard on the podium. Students who are helpful have a star by their names. Hall passes are next to the clipboard. Detention slips and referrals are on the first shelf. Please let me know how the day went by making notations on this plan, or by writing a note. Thanks.

Tuesday Schedule: 5,6,1,3

Fifth period: 7:45–9:12

7:45–8:05 SILENT READING

This gives you time to take roll, get organized, and prepare for class. Students are to be reading from a book for their book report. Some students are done with their books and may borrow magazines from the bookcase. That is allowed.

8:05–8:10 ANNOUNCEMENTS

Tell students to hang on to their homework until I return. We will take notes and correct today's homework when I return.

8:10–8:40 Get Blue literature books from behind white board and have students open to "The Nobel Experiment" on page 219.

Play audiotape and have students read along. It is ready, just push Play.

8:40–9:00 Worksheets are on my desk. Hand out and allow students to finish them on their own. They may confer with their neighbors if done quietly. Collect.

9:00–9:10 If students finish early, have them answer the questions at the end of the selection.

9:10–9:12 All work is to be turned in. Collect literature books.

(Continued)

Nutrition Break

Sixth Period 9:27–10:46 Conference

First Period: 10:53–12:14

10:53–11:13 Silent reading

11:13–11:23 Put first transparency on the overhead projector: "ANSWERS TO HOMEWORK." Have students correct their own homework. The grammar lesson is Chapter 4, Lessons 5 & 6 (marked for you).

11:23–11:33 Put second transparency up, "CHAPTER FOUR LESSONS 7 & 8 NOTES." Read over and allow students to copy. Remind students that tonight's homework is these lessons.

11:33–12:10 LITERATURE BOOKS. Allow students to choose a poem from the literature book, and answer the questions at the end of the poem, then respond to the poem using the attached directions, which they each have a copy of. They may confer with their neighbor as long as they are doing so quietly.

12:10–12:14 Collect literature book work and clean up. Literature books may stay out; the next class is using them.

LUNCH

Third Period: 12:54–2:15

12:54–1:04 Silent reading

This class is the same as first period (directly above). This class can be rather rowdy. Please be firm with them about their behavior.

2:10 Please have literature books returned to the bookshelf.

2:15 Dismissal.

Thanks. Diane

Finally, ask the substitute to leave you a note describing how the day went. You know when you return, the students will provide you with plenty of feedback about the day. It is essential that you also have a record of the substitute's impression of how the day progressed. When you return from your absence, before you tackle the messy materials or the stack of papers to be graded, look at the plans you left the substitute and any notes he or she wrote on those plans and the note left for you about the day, and file both of these documents for future reference. These documents inform you about writing better substitute lesson plans in the future and document how the day went in your absence.

CONCLUSION

Your records as a professional teacher are important documents for your own needs, to improve the quality of your instruction; for your students' needs, to provide them with clear objectives and expectations that will result in success; for your students' parents' needs, to clarify for them what is happening while their child is in your care; for your administrators' needs, to provide documentation for evaluations and reports to the district office; and finally for your district's needs, to document your professionalism in case there is ever a question regarding your classroom practices.

Managing these records requires you to keep a daily lesson book and a file where copies of all these documents can be accessed with ease. If you choose to keep these records on a file on your computer, be sure to back up the file regularly to a floppy disk. I also recommend printing a hard copy to keep on file in your desk drawer for those spur-of-the-moment meetings that may occur in your school year.

These records are the backbone of all the other documents you will want to create and keep for your school year, including the records of assessments used in your classroom.

2

Grading and Assessment Records

A teacher's greatest responsibility after providing curriculum for students is evaluating students' achievements in class. Keeping records on how well students are doing in your class is extremely important because these records will most definitely be shared with others: students, parents, administration, and, in some cases, other stakeholders, such as resource teachers or school psychologists.

I had been teaching for four years the first time a grade I gave a student was questioned. I believe the grade was an accurate assessment of the student's performance, but my record keeping left much to be desired. When the meeting was over, despite the support of my colleagues, I felt like the parents and my administrator had lost some faith in me.

A student, Lydia, had turned in a major assignment late. As a teacher I have always accepted late work, much like the phone company will accept a late payment—with a penalty. Lydia lost important points because of the tardiness of the assignment. Once the points were taken off, the assignment was only average, which was reflected in the progress report sent home.

The progress report made it home on a Friday afternoon before a school break and Lydia was placed on restriction until her parents spoke to me about the grade. Lydia had had a whole week to prepare for a meeting with me, while I showed up on Monday after a week of vacationing to be confronted with a meeting that afternoon to justify the grade Lydia received.

At the meeting with Lydia, her parents, my principal, and my team of teachers, I explained that Lydia's poetry project was turned in over a week late, and therefore had lost points, making her grade on the project a C.

I was prepared to explain that the C on the poetry project, along with some of her less-than-stellar performances on several quizzes and assignments, meant that the grade averaged out to a healthy C, passing, but only average. I didn't have the chance.

Lydia interrupted, stating that she had in fact turned her assignment in on time. She handed me the assignment with a date on it that reflected the date it was due. She argued that I was wrong and needed to change her grade. There it was in black and white, the date on the paper.

I had no indicating marks in my grade book for late work. I was not using a grading rubric that would have had the date turned in posted on it. I had only my memory and my word against Lydia's assignment with a date on it.

My principal smoothed things over, never actually siding with me, but more like playing interference for me since my argument was so weak. My team members were livid that the principal would pander to the parents instead of defending her teacher. I left wondering how Lydia had been able to make her point against me so well. The power of the written word.

I immediately began reviewing my practices so that my grades would not be called into question again, but if they were, I would be able to explain the grade clearly and to everyone's satisfaction. Four years later, I had the chance.

Melissa was the Associated Student Body (ASB) president, a cheerleader, and a C student in my Honors English class. When she received her grade, she was devastated. When I met with her father, I had all my records in order and showed him how a C grade had been earned. He nodded slowly and explained that Melissa had been so upset he had had to check, and that he appreciated the care I took in evaluating students. I wouldn't say I felt vindicated; I felt relieved that this time I had my paperwork in order.

The responsibility of evaluating students is one not to be taken lightly. "In assessing student progress and assigning grades, many teachers use a variety of techniques including examinations, term papers, project reports, group discussions, performance assessments and various other tools" (Johnson et al., 2002 p. 442). The following sections will provide you with forms and techniques for keeping records of student progress so you can evaluate student progress with clarity. They will help you

- Manage paperwork
- Provide clear and immediate feedback to all stakeholders
- Simplify how you calculate grades

DAILY GRADES

Most districts provide you with a grade book. In our district, it is a dark blue binder with the funky holes all through the middle that fit only the district-provided grade sheets. The expectation is that the teacher will use the district-provided grade sheets and binder that can be turned in to the

registrar at the end of the grading period. Some districts will also provide you with a computerized grade book, usually *A+* or *Grade Machine.* How you use these tools is left up to you—the teacher, the professional.

Many departments have a rough guideline of how grading should be done so that there is consistency from one class to the next. There is nothing worse than hearing that So-and-So is a better teacher because he grades easier. Department discussions of broad guidelines for grading help to provide students with expectations that are uniform for the entire campus.

But, unless you ask, no one gives you directions on how to keep your grade book. Most of how to keep a grade book is common sense. Some of it depends on your comfort level with organizing materials. A big part of it depends on your guiding philosophies. This book is not about what grades mean philosophically. If you are interested in exploring that topic, there are some excellent books on the market, including *Developing Grading and Reporting Systems for Student Learning,* by Thomas R. Guskey and Jane M. Bailey from Corwin Press, and *Transforming Classroom Grading,* by Robert J. Marzano from the Association for Supervision and Curriculum Development. I encourage you to look at these books to explore further what grades mean. What I will provide you with are some techniques for keeping clear records of your grades.

First, it is important to keep all records in one place. If you use the district-provided notebook and sheets, that's excellent. I like to create my own spreadsheets, which I then three-hole punch and place in a three-ring binder. In either case, your grade book sheets should look something like this:

Student Names														
Don Arias														
Chris Black														
Tonya Cuera														
Wesley Dorn														
Etc.														

Your first task is to record each student's name on your spreadsheet. The columns after the students' names give you space to record your assignments. If you are using the district-provided sheets, write them in by hand. If you are using a computer program provided by the district or creating your own spreadsheet, as I did above, type these names in from your class roster.

Obviously, having your grades on the computer saves you time in the long run. Once you have created your spreadsheet, anytime you need a

grade or a new grade sheet, you can print it out on your computer's printer rather than having to transfer all of your information onto new paperwork. Unfortunately, not all of us have computers available to us and so must make do with the resources we have available. If you have the use of a computer and have never used a spreadsheet program or one of the grading programs available, it is worth the effort to learn to use these tools. The time you spend learning to use the tools will be more than made up in the time you save keeping your records.

If you use a computer, it is also important to keep a handwritten log of your grades. The spreadsheet is easily printed out so that it looks like the above document and can be hole-punched and placed in a folder. After you have recorded your grades in your notebook, set aside time to transfer the grades to your computer. Having the grades recorded next to student names in alphabetical order in your notebook makes it easy to transfer them to the computer.

As you are recording grades, it is important to label each grade with three pieces of data. First, record the name of the assignment so that you can recall easily what the assignment was. Second, record the date the assignment was collected. Finally, record the number of points possible on the assignment.

Student Names	Grammar, Page 4, 9/10–10 pts.	Reading Worksheet – Characters, 9/12–15 pts.	Library Overview, 9/14–5 pts.	Etc.
Don Arias	9	13	4	Etc.

Having these pieces of data for each entry is important in case a student claims to have turned in an assignment that is not recorded, or a student who was absent needs to make up an assignment, and to help you to calculate your grades at the end of the term.

I find it important to record daily work daily. Stacks of papers can become overwhelming, distracting me from the papers I need to grade and keeping me from concentrating on the curriculum and work I need to assign. How you manage your daily work depends on your philosophy. Many books recommend not grading everything, or giving a pass/fail grade for daily work, while many teachers read every piece of work thoroughly. You will need to determine what works for you, making sure that you are pragmatic about your ability to keep up with your grading.

Once you have recorded the daily work in your handwritten notebook, you will want to transfer this information to your computer. Since you have already sorted through the papers and have your grades in a numerical value in alphabetical order, transferring them to the computer is a matter of keyboarding. Some teachers do this daily also, but many set aside a time once a week to input the week's grades. Inputting grades once a

week avoids having to sort through the spreadsheet program to find the one student and one assignment that was turned in late for whatever reason. Usually after a week, all student work is turned in and recorded, which makes inputting the grades easy.

Another useful tip I learned from my department chair when I was having trouble keeping track of which grades I had inputted and which needed to be done, is to highlight and date the grades in your grade book that have been inputted. A yellow highlighter lets me know where I left off in my book. I don't highlight the blank spaces in my handwritten grades because they are signals that a student has not turned that work in.

Student Names	Vocabulary 9/25 10 pts.	Reading Log 9/28 25 pts.	Quiz 9/29 25 pts.						
Don Arias	9	23	25						
Chris Black	8	25	23						
Tonya Cuera	7	21	21						
Wesley Dorn	9	23	20						
Etc.									

The black grade in the first column indicates that it still needs to be recorded. As you can see, the grades for "Vocab" and "Reading log" have been recorded but not the grade for "Quiz," which is still printed in gray.

The most important components of keeping daily grades make your system manageable considering the time constraints of a busy teacher, make your system legible so you and anyone else can make sense of it, and make your system fit your philosophy of grading.

HOMEWORK GRADES

Everyone would agree that the more you practice a skill, the better you will be at performing that skill. Homework provides a valuable opportunity to "monitor student learning, practice of a skill or concept that has been taught, tie in school learning with real-world experience, actively involve the family in the student's education and prepare for in-school activities" (Jonson, 2002 p. 133)—hence, the important role homework plays in a child's education.

Most teachers see the value of assigning homework but get bogged down in its management. Most parents see the value of homework, but get

frustrated when their children are unable to complete the homework because the assignment is too difficult for the child and parent to complete without teacher guidance. Research shows that homework that extends the learning occurring during the school day enhances a student's understanding of the subject matter (Zentall & Goldstein, 2004).

The goal for the teacher is to make the homework manageable for students and their parents, as well as for the teacher himself or herself. Creating a homework policy, again, depends on your philosophy for your instructional methods. No matter what your philosophy is, there are some record-keeping techniques that will make homework manageable for everyone.

The first step in making homework manageable is to record your policy. This may be done for you in your district policy, which is recorded in the parent handbook. Be sure to familiarize yourself with this policy so that you can act in accordance with your district's goals. Once you understand your district's philosophy regarding homework, it will be important for you to fine-tune that philosophy so it fits your philosophy and classroom procedures. You can indicate the nuances of the policy for your classroom in your letter home to parents. My homework policy reads

> I will be assigning homework Monday through Thursday. Students who feel they have no homework should spend time reading for the assigned book report or future projects. Occasionally, a student may have to work on a project over the weekend if he or she has not been able to budget weekday time accordingly.

Another teacher's reads

> Students will be given school planners and are expected to record their homework assignments each day. This is so parents may check assignments if necessary. Students will then be responsible for taking their work home, completing it, and returning it every day. Homework credit will be given for homework that is completed and returned on time. Credit will not be given for late work unless there is an excused absence or emergency.

It is important to decide on a homework policy and record that policy so that all stakeholders are clear about the expectations. Once everyone is informed of the policy, the teacher needs to record the homework assignments in a way that ensures that all stakeholders are clear about whether the policy has been followed by students.

Teachers using one policy have students copy each night's assignment from the board into their student planners. Teachers using another policy hand out a list of homework assignments for the week/month/term to each student. Which method you use will, once again, be determined by

your guiding philosophies and the resources available to you in the class. Not all teachers have student planners to give their students, and not all teachers have access to photocopying capabilities to provide students with a list of homework assignments.

However you decide to disseminate your homework assignments, some key elements are necessary for everyone to be clear about the assignments. Where the assignment is found, whether you need to list the name of the book and pages or indicate that the assignment is a handout, is crucial for the student to understand where to begin. The name of the assignment, whether it is the same name as the exercises in a book or the name of a handout, is important for students so they can be sure they are in the right place. The extent of the work to be completed needs to be clear, such as "all odd-numbered problems" or "every problem." And, the date the work is due must be made clear. Homework assignments should be listed in a way similar to the following example, whether in a printout for the students or written on the board for students to copy.

Homework for week of: _____

Monday:

Tuesday:

Wednesday:

Thursday:

Friday:

Filling this out or having students fill out a similar form will help in the communication between school and home and make support at home more likely. A sample homework form might look like this.

Homework:

Monday: <u>Reading From Scratch</u>, pages 11–12, comprehension exercises 1–19, odd only: due Tuesday.

Tuesday: <u>Grammar Handbook</u>, read pages 4–8, complete all exercises page 9, 1–10: due Wednesday.

Wednesday: <u>Reading From Scratch</u>, pages 13–14, comprehension exercises 2–20, even only: due Thursday.

Thursday: Study notes provided in class for Friday's quiz. Notes will be collected before quiz on Friday.

As students become more familiar with the textbooks you are using, you can begin to abbreviate the titles of the books. The advantages of providing clear instructions for homework are easy to recognize. Students will be more comfortable with the assignments if the instructions are clear. Parents will have fewer questions. You will have a record of your assignments for absent students, for reference when completing end-of-term grades, and for planning for the following year.

When recording homework grades, it is important that you give points according to your philosophy. Since homework is practice, many teachers give a pass/fail grade or a complete/incomplete grade. Likewise, homework becomes a small percentage of a student's grade, since students who are able to pass all other assessments without completing homework should theoretically be able to pass the curriculum, having demonstrated their proficiency. Given these circumstances, recording homework points in a consistent manner is important.

Using either the spreadsheet created for your daily grades or a new spreadsheet, recording students' earned points for homework will become manageable. The first thing to decide is whether you will grade homework daily or collect and grade homework once a week. Grading homework daily provides students immediate feedback, but requires you to budget enough time each day to grade the assignments. Grading the homework on a weekly basis cuts down on the amount of paperwork you have to manage each day and the number of grades you will need to record each week, but students are given feedback on several assignments at one time.

Student Names	Week One	Week Two	Week Three	Week Four	Week Five	Week Six	Week Seven	Week Eight	Week Nine	Week Ten	Etc.			
Don Arias														
Chris Black														
Tonya Cuera														
Wesley Dorn														
Etc.														

You will notice on the above spreadsheet that the homework is simply labeled by week. If you have recorded your homework assignments for your own records in your lesson plans, and for your students on the board or in a handout, as long as each week is clear you need not record all the data again here. Once you have recorded the points earned by each student, you can transfer these grades to your computer.

Keeping homework grades separate from daily grades allows you to see which students are consistently completing their homework and which need more support in this area. This also allows you to determine

the role homework is playing in a child's success in your classroom. Generally, students who are struggling with the curriculum also are not completing their homework, which would alert a teacher that the situation needs to be further investigated.

MAKEUP OR LATE WORK

Whether or not you accept late work, you will need to deal with assignments that are turned in later than the announced due date because of student absences. Keeping track of these assignments can be difficult because they are strays, not turned in with the stack of other students' work. It is important to keeping good records that you have a system for keeping track of these papers.

Most states have a law requiring that teachers provide assignments for absent students. If the absence is due to an extended vacation, family business, or prolonged illness, the student is usually placed on "independent study" for the duration of the absence. It is the teacher's duty to provide work that approximates what is occurring in the class despite the fact that the student will miss important lectures, instructions, clarifications, and classroom interactions, all of which aid in the comprehension of new concepts and assignments.

Your first order of business is to make sure the student is clear about what the makeup work is. Most school districts have a policy regarding long absences along with forms to be completed. If you are not already familiar with these forms, be sure to take a close look at them. The forms will include the following information:

Student name: _____

Class: _____ Teacher: _____

Dates to be missed: _____

Objectives: _____

Materials: _____

Assignments: _____

Method of evaluation: _____

Student signature: _____

Teacher signature: _____

Parent signature: _____

Assignments will *not* be accepted after _____

If your district or school site does not provide you with a form similar to the one above, it is in your best interest to use the one above or create your own. The information required on the form helps to clarify for all stakeholders what the expectations are for assignments when there is an extended absence. As the teacher, you may simply be able to open your lesson plan book and copy down the objectives, materials, and assignments from the book. But, since the student will miss important classroom time, you may need to adjust the assignments to ensure the student is able to complete them on his or her own.

The other type of makeup work you will need to deal with is work that a student missed because of a day or two of illness. This is easier for the child to make up, but should not be taken any more lightly. It may be tempting to simply tell the student to get the assignments from the board or from a classroom partner and leave it up to the student to complete the work. If the student fails to do so, and a question arises over why the student is missing so many assignments, you won't appear at your professional best if you shrug your shoulders to explain it was up to the student to get the work.

A better method is to be sure to place the absent student's name on all handouts for the day, to provide the student with a copy of your notes for him or her to copy or to keep, and a note from you indicating the due date for the missed work.

Name: _____ Date(s) absent: _____

Assignments for your absence are attached or listed below. Notes are attached that you must copy and return. These assignments are due _____ days from now, on _____.

It is best if you are able to make a notation that you provided these materials to the student by having the student sign for them. Create a form for students to sign when they return from an absence indicating that they received the assignments.

Name: _____ Date returned: _____ Assignments received: _____

1. _____

2. _____

Now the responsibility is on the student to complete the assignments and return them to you. The student should return the packet in its entirety, whether or not it is complete. When you receive the packet, you should initial the due date, indicating it was turned in on time.

The next order of business is keeping your grade book straight when receiving late work. Remember that you are entering grades into your notebook and highlighting them when you enter the grades into the computer. Empty spaces in your grade book that are not highlighted indicate late work. It is important to record the grade in your notebook, then to update your computer, highlighting the late grade in a different color to indicate it was entered later than the rest of the grades.

Once you have entered the grade, you can return the work to the student. These steps for taking care of late work—filling out a form, collecting the work and notes, having a student sign for them, and recording the grades—may seem like a lot at first, but once you have the system down, you will ensure that the student receives makeup work, will be able to fend off accusations that a child is failing because you were irresponsible, and will save time by using a system to keep up with informing your students of work that must be made up.

INCOMPLETE WORK

Students often turn in work that is incomplete. Once again, your philosophy will determine how you handle this work. Whether you grade the portion of the work that is completed and give points or a grade for that part or return the work ungraded, indicating the need for completion, it is your responsibility to indicate in your records that the work was turned in, incomplete.

Many teachers, whether they grade this work or not, return the work with a notice of incompleteness that must be signed by a parent or guardian before a grade on the work is recorded.

Dear: _____ (parent or guardian),

The attached work has been turned in incomplete. I wanted to bring this to your attention as incomplete work could jeopardize your child's ability to meet the requirements of the curricular standards. The grade for this assignment will not be recorded without your signature.

Thank you,

(Teacher)

Parent's signature and date

Once the assignment has been returned, you can tear off the note, place it in your files, and record the grade. Not only does this short note notify

parents, it will help gain their support for an errant student, alert the student that there are consequences for incomplete work, and provide you with a paper trail of notification for struggling students.

Other teachers simply refuse to grade incomplete work, indicating with a large "INC" on the work that it needs to be completed before it will be graded. If you handle incomplete work in this manner, it is important to date the "INC" so there is no confusion about when you received the work and when you returned it to the student. If this is your policy, students need to know your requirements for how long incomplete work will be accepted. The policy should be stated in your classroom procedures letter and could look like this:

> Incomplete work will be returned with an INC and a date on it. The work will be accepted no later than one week after the date next to the INC and the grade will be compromised.

Notice that the policy states that the grade will be compromised but is not specific as to how. This vagueness allows you to adjust the policy as the situation dictates.

Finally, your grade book should indicate which assignments were turned in late. Depending on your policy, you will want to record the grade in such a way that when you look at your grade notebook, you can interpret the marks indicating which grades were recorded even though the assignment was incomplete. I indicate this in my grade notebook by circling the recorded grade. When I look in my grade notebook, I can see if there is a pattern of incomplete work for a student that requires that the situation be further investigated. A circle works for me, but any type of indicator is fine as long as you understand your marks. For purposes of this example, I have indicated the incomplete work with a strikethrough.

Student Names	Vocabulary 9/25 10 pts.	Reading Log 9/28 25 pts.	Quiz 9/29 25 pts.					
Don Arias	9	~~23~~	25					
Chris Black	8	25	23					
Tonya Cuera	7	21	21					
Wesley Dorn	9	23	20					
Etc.								

I know many teachers do not accept late work. I happen to be one of those softies who does. I penalize a student for late work, just like the phone company accepts my late payment with a penalty assessed to it. I use underlining in my grade notebook for assignments that are turned in late.

Student Names	Vocabulary 9/25 10 pts.	Reading Log 9/28 25 pts.	Quiz 9/29 25 pts.					
Don Arias	9	23	25					
Chris Black	8	25	23					
Tonya Cuera	7	21	21					
Wesley Dorn	9	23	20					
Etc.								

This allows me to keep track of work that consistently gets a lower grade, not because the work is difficult for the student, but because the student fails to turn it in on time. When I look back at my records, my notations clarify for me and other stakeholders what is happening with each student.

Accepting incomplete or late work is an individual preference. Some teachers may avoid all of these record-keeping techniques by stating in their classroom policies that incomplete or late work will not be accepted. But, if you do accept these assignments, it is important to keep your records straight about what was turned in and when.

CLASS PARTICIPATION

Keeping track of a student's class participation can be daunting. As a teacher you want to fully engage all your students, and writing notes about these interactions can distract you from fully engaging with your students during class discussions. Because of the difficulty of simultaneously fully engaging students and keeping accurate records of these interactions, many teachers choose to not record these interactions and do not include them in the students' formal grade.

Given what we know about the many ways students learn and exhibit what they have learned, whether you call it multiple intelligences or learning styles, it seems irresponsible to not give credit to those oral, auditory

learners who thrive during class discussion/participation time but struggle with written work. Also, classroom interaction time that is not monitored for equality can become dominated by the one or two bright students on whom the teacher can depend for correct answers. All the other students know Jason will answer all of the questions, so they tune out of the class activities during this time. For more information on this, check into TESA (Teacher Expectations & Student Achievement), a program offered by the Los Angeles County School District online at www.lacoe.edu.

As a teacher, you are responsible for the learning of all your students. It is important for you to employ some techniques that make class discussions equitable and hold all students accountable for participating.

You will want to begin with deciding how you would like your students to participate in class. Holding unstructured discussion results in little learning. But structured "class discussion is a useful strategy for stimulating thought and encouraging students to re-examine their attitudes" (Partin, 1995 p. 114). Requiring students to participate in question-and-answer sessions helps a teacher check for understanding and allows students review time for key concepts. Both of these elements of class participation are important for a healthy classroom.

One way to record class participation, whether in a class discussion or a question-and-answer session, is to rely on your spreadsheet printout:

Student Names																
Don Arias																
Chris Black																
Tonya Cuera																
Wesley Dorn																
Etc.																

Use this printout much the way you would use it for recording points on assignments—during class participation time, you or a helper checks off each time a child participates. By checking students' names as they participate, the teacher allows students the opportunity to participate when they feel comfortable; the marks are positive marks. The teacher needs to mark at the top of each column the date and discussion or question-and-answer topic for his or her own records.

Another way to use the printout is for the teacher to direct class participation by calling on students, either in order or randomly, and marking only those students who fail to participate by responding with "I don't

know" or who answer incorrectly. This method ensures that all students are held accountable for participating in the class and for understanding the topic.

In either case, the form can be held until the end of the term, at which time the teacher can use this record to inform his or her formal grades, to help with citizenship marks, or, if a student has developed some alarming patterns, to further investigate the situation.

Another method for recording class participation is to hand out tickets. Giving each child a predetermined number of tickets at the beginning of each unit of study and explaining to the class that they must turn in a ticket each time they participate in class discussions or question-and-answer session leaves it up to individual students when they want to participate.

Name: _____ Date: _____

Topic: _____

My participation: _____

The great thing about using the tickets is that the responsibility for participating is placed on the student. The student simply holds up his or her ticket when he or she is willing to participate. Also, students who have already turned in their tickets can continue to participate without using a ticket as long as they understand that the teacher will give students with tickets priority in the proceedings.

At the end of these class participation sessions, the teacher records on a spreadsheet those students who turned in tickets. The teacher does not need to indicate which day or discussion the student participated in, because the teacher will file away the tickets in case that information is needed later for any reason.

If you decide to use these oral activities as part of your assessment of the students' demonstration of mastery of the curriculum, you can transfer the data to your grade book when completing end-of-term grades.

RUNNING RECORDS

Keeping track of student participation is very close to keeping running records of other student activities that do not result in a paper or project being turned in for evaluation, but still indicate that learning is occurring. As mentioned earlier, when accounting for other methods of learning or multiple intelligences, it is also important to assess the other forms of learning that students participate in during class time.

Keeping running records of student activities in class can seem unconquerable at first, given everything else you have to do, but if used correctly, running records actually increase time on task by decreasing your

need for classroom management or discipline techniques. Keeping running records on students requires you to pay attention to every student at some point during your classroom time. It may not be every day, depending on how you organize your records, but students are never sure when it will be their turn, so they are on their toes at all times.

As an English teacher, I know that sustained silent reading is one of the best teaching tools I can use in my classroom to encourage my students to become proficient readers. The problem was that being a middle school teacher meant that I had to have some structure that made my students accountable for their choices during this time. I began to use running records.

Using a printout of my spreadsheet with student names, I began a point system for students who were reading, students who were searching for a book or engaged in activities other than reading, students who were off task, and students who were disruptive.

Student Names															
Don Arias															
Chris Black															
Tonya Cuera															
Wesley Dorn															
Etc.															

I would simply place the date at the top of the column, and at the beginning of each reading session, I'd mark points for each child's choice. The points worked like this:

3: On task, quietly reading book

2: Quietly engaged in activity other than reading book

1: Off-task but quiet

0: Disruptive

The points take the grade out of my hands and place the responsibility on the student and his or her choices during this time. I also would record things like students choosing to leave the class during this time, writing RR for restroom, OF for office, NU for nurse, or LI for library in the space. I don't give points to students who choose not to participate during this time by leaving the class. The record not only indicates to me who is using this time wisely, but also who needs more guidance and who needs fewer restroom passes.

Another type of running record is the anecdotal record, which is useful for monitoring group work or project work. It is best to choose four or five students to focus on each day during this classroom activity, never letting the class know which students you will be monitoring for your records. Using a form, wander around the classroom and make notations about what is occurring.

Date: _____ Activity: _____

Student: _____

Notes: _____

These notes can be filed in a student's folder to help you assess such things as time on task, brilliant insights, or good leadership. The great thing about anecdotal records is that even though you have four students on whom you are focusing, if other students are participating in meaningful ways, there is nothing to stop you from recording those occurrences also.

If you run out of forms or just want to use another format, you can simply walk around, making notes on a pad of sticky notes that you later transfer to the students' folders.

Running records can be translated into citizenship grades or can be assigned points, as I did for silent reading participation. The important thing is that you, the teacher, have records indicating what students are doing during class time, students know that student-directed time is important and meaningful enough for you to be recording how they are participating, and your classroom management during this time becomes positive.

GRADING CHECKLISTS AND RUBRICS

So far we have looked at ways to record daily activities in your classroom, from daily assignments to homework to class participation. Now it is time to look at how to keep records of major classroom assignments, whether they are long-term projects, essays, or cumulative assignments.

The first step in keeping records on these long-term assignments is giving clear, written directions for the assignments (see Chapter 1). Once a student has a clear set of instructions, has been provided with access to the materials needed to complete the assignment, and has had plenty of time to complete the assignment, the project is turned in to you, the teacher.

Recording the completion of this large assignment is much more complicated than assigning points or marks, as was necessary for smaller assignments. After all, this assignment was planned to give students an opportunity to show what they know about a subject on a variety of levels,

and a simple A or B or C scrawled at the top of the page doesn't do the assignment justice. This is where grading checklists help you, the teacher, justify the grade earned on the assignment, give clear feedback to the student, and create a document that can be filed as part of your records to demonstrate the student's accomplishments in your classroom.

Grading checklists make your expectations for an assignment very clear. Many states are increasingly grading assessments using rubrics, because the rubrics enable assessors to make objective, criteria-referenced judgments about student work. A checklist is a time-saving method of giving clear feedback without investing as much time as a rubric requires. When using a checklist to grade an assignment, the work itself earns the grade, not any other extenuating information you may have about a student.

You need to generate a list of expectations for what will be evident in the assignment, assign a point value for completion of each of these expectations, then print it out in a manner that makes your grading of the assignment very clear.

For instance, each year my students send a letter to an author of a book they have read. Below is the grading checklist for the assignment:

Name: _____

Letter to the Author

Book Report

Date, salutation, closing (10 points) _____

Your address (10 points) _____

Author and address (10 points) _____

Paragraph introducing yourself (15 points) _____

Paragraph explaining which book you read and
why (15 points) _____

Paragraph describing your favorite part of book
(15 points) _____

Pride in presentation (10 points) _____

Mechanics (15 points) _____

TOTAL (100) _____

As you can see, the checklist makes it very clear how points are earned and where points would be lost on incomplete assignments. You will find it useful to indicate other data on the rubric, such as whether the assignment was turned in late, words were misspelled, or if something was done incorrectly. The checklist allows you to write brief notes to students about errors without having to remind them of the expectations.

I find students are more successful with assignments if they have the checklist before the assignment is due. Having the checklist allows them to go over each set of points and how to earn them to be sure they have completed each part of the assignment.

The previous checklist is based on a grading system that uses points. Once you have checklists completed for projects and you have made sure your expectations for the assignment are clear, you may want to create a more detailed record for grading these assignments, such as a rubric.

Rubrics are often best completed working with other teachers using the same assignment or project. Working with colleagues helps clarify appropriate grade-level and schoolwide expectations. Many districts and teachers are beginning to use rubrics that are grade related, such as the following:

4 A	3 B	2 C	1 NC
Mechanics: No spelling errors No grammar errors Neat copy	Mechanics: Few spelling errors Few grammar errors Legible copy	Mechanics: Many spelling errors Many grammar errors Copy difficult to read	Unreadable due to poor spelling, grammar, and penmanship
Content: Ideas insightful	Content: Ideas clever	Content: Ideas organized	Content: Lacks controlling idea
Organization: Well-organized with transitions	Organization: Beginning, middle, and end	Organization: Lacks organization of ideas	Organization: No paragraphing No beginning, middle, or end
Voice: Tough to put down Uses vocabulary beyond grade level	Voice: Shows some sparks of spontaneity Uses appropriate vocabulary	Voice: Functional, often sincere—though sometimes distant Uses vocabulary below grade level	Voice: No sense of person behind the words Vocabulary not appropriate for subject

This rubric also makes clear the expectation for a paper written for an English class and allows the teacher to mark where the student has met the expectations and what the student needs to improve.

Another possibility for rubrics is to graduate one of your checklists into a rubric. The following is a rubric for the assignment "Letter to the Author":

Letter to the Author				
Parts of Assignment	*10*	*7*	*3*	*0*
Business Letter Requirements	Date, formal greeting, and closing	Missing one requirement	Missing two requirements	Not attempted
Author's Name and Address	Name and address in proper format, including "In care of" if necessary	All of pieces for address present but not in proper format	Elements of address missing	Not attempted
Return Name and Address	Name and address in proper format, including "In care of" if necessary	All of pieces for address present but not in proper format	Elements of address missing	Not attempted
Introduction Paragraph	Introduces self and describes personal facts that will connect with the book read	Introduces self but fails to personalize information	Only tells author name	Not attempted
Book You Read Paragraph	Title of book and why you chose it, tying it to personal interests	Title of book mentioned and choice for impersonal reason	Title of book, but why you chose it is not explained	Not attempted
Favorite Part Paragraph	Specific part of book you liked and why it was important to you and the story	Favorite part is mentioned but vague	No specific part mentioned	Not attempted
Conclusion	Thank author for time and extend communication	Thank author	Conclude in impersonal manner	Not attempted
Pride in Presentation	Blue or black ink, one side of paper, neatly written or typed	Blue or black ink, neatly written	Ink, readable	Pencil, frequent mark outs
Conventions	Only the pickiest editors will find mistakes; ready to publish	Noticeable but minor errors; do not hinder meaning	Frequent errors that make reading distracted	Extensive word-by-word editing needed
Sentence Fluency	Crisp and to the point, easy to read with inflection	Grammatical, natural, pleasant phrasing	Mechanical but readable, some run-ons or fragments	Can be read aloud only with extensive editing

As you can see, creating this rubric takes much more time than creating a checklist, but it gives students a much clearer picture of expectations and allows the teacher to grade based solely on performance on the assignment.

Both types of grading records give clear feedback to your students and allow you to record specifically how a student performed on the assignment, and should evolve as you use them (Arter & McTighe, 2001).

Checklists and rubrics are great documents to place in a student folder or portfolio as a record of how a student is progressing in your class. Especially when the assignment is not conducive to storing for future reference, a record of this kind allows teacher and student to reflect on how a student performed on an assignment.

TESTS

As high-stakes tests increasingly take center stage in education, more of our efforts are focused on preparing our students for those tests. As with any activity, the more practice students have at taking tests, the better prepared they will be for taking them. So, as teachers, we begin to rely more heavily on tests for our assessment of our students. "Most assessments in schools are tests or quizzes" (Slavin, 2003 p. 465).

Since the goal of tests and quizzes is to assess how well students learned the curriculum, the scores for these assessments are a very important component of your records. Some teachers base most of their final grade on test scores, reasoning that if students cannot demonstrate what they know on a test, they don't know the material. These same teachers often allow students to retake tests until they have mastered the curriculum, realizing that the goal is not to fail students, but to have everyone in class master the content of the curriculum.

Besides the formal grades you send home, the one other piece of educational information all parents receive is how well their child did on the high-stakes state assessments. It is important for parents to have a well-rounded view of their children as students, rather than rely on one high-stakes assessment for their perception of their children as learners.

Some students are simply poor test takers. Some are excellent test takers who have an advantage if testing is a teacher's major form of assessment for the class. Whether you rely heavily on tests and quizzes to monitor how well your students are performing in class, or not, tests and quizzes are an important part of any classroom, and the records for these assignments must be kept diligently.

It is important to keep a copy of all tests and quizzes on file in case there are any questions regarding their validity. Your method of scoring tests must be clear. Often, the points for each answer are stated directly on the test so there is no confusion. Be sure to record everyone's scores on the spreadsheet.

Student Names													
Don Arias													
Chris Black													
Tonya Cuera													
Wesley Dorn													
Etc.													

As with other assignments, the date the test was given, the topic, and the possible number of points are all important pieces of data that must be recorded. You also need to be prepared for students who will take the test late due to absence or students who will need to take a retake test (often similar subject matter but different questions from the original test). To indicate that a student has retaken a test because he or she was not successful on the test the first try, I cross out the original score then write the new score above it.

Student Names	Poetry Quiz 9/25–50 pts.												
Don Arias	48 ~~34~~												

Then I update my computer files.

It is important to clearly label all pretests and posttests. These tests are given to measure growth from the beginning of a unit of study to the end of the unit. You may want to create a separate spreadsheet just for this information and then calculate the growth for your students based on this spreadsheet.

Student Names	Reading 8/23	Reading 5/26	Change									
Don Arias	34	48	+12									
Chris Black	12	25	+13									
Tonya Cuera	56	58	+2									
Wesley Dorn	34	26	−12									
Entire Class Scores												

Setting up your spreadsheet this way not only informs you about individual students, but can inform you about how well your instruction promoted growth in reading for students. Wesley Dorn would concern me, because despite being with me for the year, his reading score has gone down significantly. This is a situation that would require my attention immediately.

It is becoming more and more important to keep records of your students' tests as testing in this country gains more support from the government and the public.

FINAL GRADES

It was the last meeting for a college course and the professor spent the time calling each one of us and asking us what we thought our grade should be. I was irritated beyond belief. First, I had better things to do than sit around waiting for my turn to inform my professor what my grade should be, and second, if my grade was so nebulous as to boil down to my opinion, what was the point of all the work I had done over the course of the class?

Our students often feel the same way. They say things like, "You failed me" or "Thanks for the A" as if they had nothing to do with the grade they have earned. I always respond to these comments by reminding students they earned their grade with their achievement. I had little to do with it. But, they need proof.

With the proper record keeping, you can show students and their parents how they earned their grade in your class. Keeping all of your grades on a spreadsheet program makes it very easy to print out each student's grade.

Don Arias	Vocabulary Points	Grammar Points	Reading Points	Homework Points	Test Points	Total
	33/40	25/40	40/40	35/40	45/50	178/210 = 84%, B

By providing students with this document, you take the guesswork out of how they earned the grade they did.

Your district provides you with a system for reporting final course grades through your registrar, and the records you keep should easily translate into those forms. You will use your philosophy about grades and what they represent in your class to translate the records you keep for a term to determine each student's end-of-course grade. Remember, once you have filled out the official end-of-term grade, your records must be turned in to the registrar for his or her records, in case there is ever a question later about a grade. Be sure to keep a copy of your records even after you provide your school site a copy.

SAMPLE WORK AS RECORDS

One of the best ways to assess what is happening for students in a class is to collect samples of their work. Keeping samples of student work is a great way for you to track the quality of work a student is turning in, to track growth from the beginning of the school year to the end, and to track the level of difficulty and engagement that your curriculum requires of students.

Collecting the work is another matter. In a perfect world, whenever students did work they wanted included in their portfolio, they would walk over to the copy machine or scanner in the classroom and make a copy for their folder in the filing cabinet or on the computer. If you have this capability, then this process is quite easy. If not, then there needs to be a bit more management involved.

The problem presents itself when you want to send work home with students so they have their work in their possession, and you want to hang on to work for your records. Many teachers simply ask students for permission, believing that most of the work sent home ends up in the trashcan anyway. Some pull the work they would like copies of from the stack, make copies, and then hand the originals back to students. This is a solution, but is very time-consuming. Still others use cameras to take photos of work, but you must have that technology available to you. However you are able to solve this dilemma, if it is one for you, the rewards of keeping student work will be well worth the effort.

Once you have selected a piece of work for a student's portfolio, you will want to include the grading rubric with the work and have the student reflect on the piece of work by filling out a short form to attach to the sample.

Assignment: _____

Grade earned: _____

Describe the procedure for completing this assignment: _____

Describe the result of your effort: _____

What are you most proud of on this assignment? _____

If you could do it over, what would you change and why? _____

This short form involves students in the recording of their sample work and gives you one more piece of data to use when reflecting on the growth of individual students (Benson & Barnett, 1999).

Sample student work is very powerful in all meetings you attend, whether with a student's parents or your administrator. Student work is truly a representation of what is happening in your class and well worth the effort to collect for your records.

PORTFOLIOS OR STUDENT FILES

There is a continuum that involves the difference between teacher-maintained student files and student-centered portfolios. Ideally, we all would have our classrooms organized so that students create and maintain portfolios. Often, our circumstances require that we rely on student folders for the purposes of keeping records of student work.

The difference between a teacher-maintained student folder and a portfolio is really the amount of control and involvement a student has in the selection of the work placed in the file. Portfolios in their purest form are student directed, student maintained, and student assessed. Student folders, on the other hand, rarely involve the student in selecting the work, maintaining the work, and assessing the work; all of this is left up to the teacher.

These files have "important uses when teachers want to evaluate students for reports to parents or other within school purposes" (Slavin, 2003, p. 497). The files can have "several goals: to show growth over time, to show the breadth of achievements and to showcase the student's best work" (Johnson et al., 2002, p. 544).

The first step to creating these files is to actually create a file folder for each student. Large pieces of construction paper folded in half can work as well as traditional file folders. If you have access to computers and scanners or digital cameras, you can easily create a file for each student on your computer.

Once the files are created, you must decide what will be placed in them. All of the records you have maintained throughout this chapter should be included in the file: pre- and posttests, major assessments or grading rubrics of those assessments, running records, and final grades.

The file can easily be pulled anytime during the course of the term for meetings with parents, for meetings with other teachers, for meetings with the student, or for your own reference if a situation arises that requires further investigation.

At the end of the term, you and the student can review what has been placed in the file and make some assessments. Depending on what has been placed in the file, an assessment of the work can look something like this:

Name: _____

Pretest score: _____ Posttest score: _____ Improvement: _____

First essay score: _____ Last essay score: _____ Improvement: _____

How I improved on tests:

How I improved in my writing:

What I still need to focus on:

What strengths I can build on:

Having students reflect on the work kept in the file allows them to "see their own growth. [This] process, by nature, requires students to engage in higher-level thinking skills. Students will have to reflect on the quality of their work" (Thompson, 2002, p. 241). The filing this system requires is repaid when students view the quality of their work over the course of the year.

The file can be sent home for parents to view. If it is the end of the term and your school has a system of passing files on to the next teacher, you will need to collect these files from the students after their parents have seen them. Otherwise, send the files home with the students, encouraging them to store their files for posterity.

ATTEMPTS TO PROVIDE SUPPORT

Many of the records discussed throughout this chapter are records you can use to provide evidence that you have done everything reasonably possible to provide support for a student. When we recognize that a child is struggling in class, our first responsibility is to provide as much support as possible. If your support is not enough, it is time to make a referral for a special program. Many school districts require records that demonstrate that the student is still struggling despite everyone's best effort to help the child.

Your spreadsheets, with their records of daily work, homework, and incomplete or late work, will reveal a pattern if a child is struggling. Your marks indicating incomplete work returned for completion and parent notification of this situation represent an attempt on your part to notify everyone and to allow the student to improve his or her standing in class.

Your running records will show the types of choices the student made during the course of class time, whether during whole-class activities or individual activities. Grading rubrics will have recorded on them common mistakes a student may have made that were not corrected despite your extra support to resolve these gaps in learning. Finally, grades and a file of student work are both evidence of achievement by the student.

When you have a student who requires more assistance than is possible in the regular classroom setting, these records will help to make a case for more assistance for the child.

CONCLUSION

Keeping clear records of student achievement can be the most time-consuming part of your job, but if you create a system that helps you to manage the paperwork; provides clear and immediate feedback for students, their parents, and other stakeholders; and simplifies the manner in which you calculate your grades, then the time is well worth it. You will find that once you have an organized system for keeping these records, the time spent will dwindle because of your careful planning.

All of these records become the backbone of your parent-teacher meetings and will help those contacts run smoothly.

3

Classroom Management Records

My sixth-period class was what we professionals like to call "challenging." I had a group of boys who were Beavis and Butthead fans and spent every moment my back was turned throwing things or distracting one another by making rude noises. I tried every trick up my sleeve to control their behavior, and over the course of my time with them, their behavior improved enough to allow me to conduct class.

On the last day of class, one of these boys decided to disrupt finals. I collected his final project and excused him to on-campus study hall for the remainder of the class. At the end of the day, after all the students had gone home, I received a phone call from the boy's mother. She was livid. I assured her that John would receive full credit for the project, but I just couldn't allow him to disrupt the final day of class. This didn't calm her down. Instead, she accused me of picking on her son because I didn't like boys. It seemed that John had convinced her over the course of his time with me that I didn't like any boys and was mean to all of them. I explained that I not only had a son, but wouldn't dream of treating a student differently based on gender.

She didn't believe me, and it was my fault. John had behaved poorly for me all year, and I had failed to notify his parents or document any of his behaviors, believing none of them were malicious enough to warrant

the extra attention and time it would have taken to document what was happening. I have since learned that if I document minor infractions, there is a greater likelihood of the more disruptive behaviors never occurring.

Most veteran teachers will agree that if you can manage children, you can teach them. It doesn't matter how well you know your subject matter or how enthusiastic you are about your love for children. You must be able to manage their behavior to have a well-run classroom.

If you are struggling with a student—even veteran teachers have this problem from time to time—and need outside support, having records of all you have done to resolve the problem will not only show that professionally you are doing your best, but prevent your support staff from having to repeat the many steps you have already taken and enable them to solve the problem quickly.

Classroom management records include any paperwork generated that records action taken to monitor, adjust, or change the behavior of students in the class. This paperwork includes things like seating charts, notation of off-task paperwork, consequence papers, and behavioral plans. These records will help you do the following:

- Remove the subjectivity of management
- Promote discussion of appropriate behaviors and problem solving
- Encourage support from outside resources

SEATING CHARTS

Research shows that where individual students sit in class has an effect on their success in class (McCroskey & McVetta, n.d.). We've all heard of the T effect; the students sitting in the front and down the middle get the most teacher attention and therefore perform better in class. Many support programs—504s, IEPs (individual education plans), and AVID (Advancement Via Individual Determination) plans—request that teachers give these students preferential seating.

Teachers move students who need extra attention to the front quite naturally, understanding that close proximity to the teacher reduces the opportunity for off-task behavior. Seating charts are an excellent way for you to keep track of this management tool.

First, you will need to set up your seating chart. You must decide on a furniture configuration for your room that facilitates all that occurs in the class as well as considers the constraints of your room, its layout, and the students. Once you have organized your class, draw a map of the class. The map can be hand drawn or computer generated:

Make several copies of this map and begin to fill it in with students' names. At the beginning of the year, when you do not yet know the

Bookcases

Door Back of class

Overhead Bookcase

Teacher's desk

students or their specific needs and your goal is to learn their names, it will probably be easier if you place everyone in alphabetical order.

As the year begins, you will start to find out from support teachers which students must have preferential seating due to legal requirements. Plus, as you become familiar with your students, you will know which ones need to be close to you to help them pay attention. Once you start to rearrange seats, your record keeping begins.

Instead of erasing names and moving people, make a new seating chart the first time you change seats. Typically, the changes will be dramatic enough that they will warrant a new seating chart. Each time

after this initial change, you will probably be moving only a few students. To keep a record of the date you changed someone's seat, you simply cross out the name with a date and write in the new name.

Bookcases

Door Back of class

Michae Manning	Jose Ontrea	Julia Hild		Charlie Bloom	Jon Bush	Fred Stone
Aaron Umber	~~Bill Ehler~~ Kyle Walls	Tanner Perty	Rachel Ward	Mike Dasick	Wes Gesh	Tricia Dish
~~Danile Young~~ Kim Capari	Jesse Intery	Jessica Wannale	~~Kim Capari~~ Danile Young	Angel Huber	Tonya Shiling	Linda Kening
Boyd Dimwitty	Troy Quicko	Heidi Forest	Bea Trundle	~~Lisa Muttz~~ Josimar Hernan	Omar Ilan	Jennifer Lopiz
Veronica Tittle	Aisha Washington	Blake Verious	Tom Wells	Karen Toms	Santi Ocampo	Toun Moani
Nathan Opin	~~Josimar Hernan~~ Lisa Muttz	Teri Boyd	~~Kyle Walls~~ Bill Ehler	Lois Lucky		

Overhead Bookcase

Teacher's desk

Once your seating chart becomes too messy for your comfort level, make a new one and file it in your desk drawer. Be sure to date the new one.

Seating charts are a great way to indicate the extra attention you are capable of giving students with special needs in your classroom by seating them in closer proximity to instructional materials or your lecture area, or out of focus of distractions.

STUDENT-GENERATED OFF-TASK PAPERWORK

No matter how structured a student's time, or how much we dissuade our students from being off task, there will be times when you are wandering around the classroom and stumble upon a child drawing a picture, writing a note, or doing homework for another class.

Your personality and teaching style will determine how you react to such an infraction. The important thing is creating a record that it occurred. The easiest thing to do is to collect the note, picture, or homework; initial and date the top; and ask the student to see you after class.

If the collected work is homework for another class, or some other paper that is very important to the student, he or she will approach you after class and ask to have it back. In order for you to keep a record of the collected work, have the student fill out a form indicating your return of the work. It could look like this:

Name: _____ Date: _____

Paper returned: _____

Reason it was collected by teacher: _____

Student signature: _____

Trade this slip of paper for the paper the student wants, and you have created a record of the off-task behavior.

If the student does not approach you for the paper, then simply file it away after dating it and noting what the student should have been doing. The paper serves as a record that the student was engaged in an activity other than class work.

TIME-OUTS

A very effective way to stop disruptive behavior is to take away a student's audience. You can eliminate disruptive behavior with time-outs. Make arrangements with another teacher on campus to send your offending students to one another as needed. This removes a disruptive student from his or her audience and gives you a tool for handling the disruption immediately.

It is important when you send a student out of class that you provide the student with comparable work and with directions for when to return.

A form that gives the student directions and on which you can write the assignment also gives you a record of the incident.

Time-Out

Name: _____ Date: _____

Go to Room #: _____

Assignment: _____

Return to class at: _____

When the student returns with the paperwork, you can mark on this form whether the assignment was completed and then place the assignment with the work you collected from the students who were in class.

This paper allows the teacher watching your student to write you a note if the child remained disruptive. It also provides you with a record of the situation. Once you have this paperwork, file it in a folder in case you need it in the future.

DETENTIONS

Assigning a student a detention is never a pleasant situation, but often it is required if students are to understand that if they waste class time, there will be a direct consequence, namely the loss of their free time. How detentions are assigned varies from district to district, even from school to school. It is important that you understand the policy on your campus and adhere to its guidelines. If you are capable of assigning detentions, there are steps you will want to take to ensure that they are successful in modifying student behavior.

If a detention is assigned to a student, it is important that the reason for the detention is clear and that parents are notified before the detention is served. This is important because then you have the parents' understanding of what is occurring in class and that the consequence is meant to help their child be successful in class.

Many schools provide a detention form that the entire school uses. If not, you can create your own. Be sure it includes the following information:

Detention Slip

Date: _____

_____ has been assigned
a detention for the following infraction:

_____ Classroom disturbance _____ Failure to bring materials to class

_____ Excessive tardiness _____ Inappropriate physical contact

_____ Verbal threats or _____ Other:
 profanity

The student is to report to Room _____ at _____. Detention will last
for thirty minutes and will be spent working on _____.

Parent signature _____

Once the detention has been assigned, it is the teacher's responsibility
to make sure that the detention is served in a timely manner. If it isn't, a
more severe consequence should follow. To keep track of who owes you a
detention, you can add a reminder slip to the bottom of the detention form.
It might look like this:

Detention assigned to: _____ on _____
for _____.

Keeping the reminder in a prominent place will ensure that you hold
students accountable for their consequence.

During the detention, you can use the detention slip to take notes on
any aberrant behavior or to indicate that the detention was served without
incidence. Once the detention is served, simply noting this on the slip and
filing it away will serve as a record not only of the infraction, but also of
the consequence being fulfilled.

DISCIPLINE REFERRALS

Writing a discipline referral should be a last resort. A teacher should not
get to this point in the discipline procedures until every other consequence

has been given. Once you as a teacher decide that a discipline referral is necessary, it is extremely important that you have good records of the interventions already tried, because you will want to assure all parties involved that this measure is not unwarranted.

As with detentions, most schools have forms to be used in this case. The example below is for reference; it shows the information you will want to include on the referral.

Discipline Referral

Student's name: _____

Class: _____

Place of incident: _____ Time: _____

Teacher: _____

Reason for referral: _____

Details: _____

Actions taken prior to referral: _____

Comments: _____

Filling out a discipline referral is not something that should be done quickly. You may be tempted as a teacher to scribble as fast as you can so as to get rid of the offending student and get back to teaching class, but the referral needs careful attention.

First, it is important that you state the reason for the incident in clear, unbiased language. Keeping your feelings or concerns out of the description of the infraction allows discipline personnel to read back to the student what you have reported occurred. This helps them gather information from the student.

Second, you will want to clearly mark the interventions you have already tried, whether or not your school's referral form requires this. This reassures discipline personnel that you are not "just having a bad day." Record all of the interventions you have tried, including counseling the student, phoning home, changing seats, time-outs, and detentions. Placing

a date next to each item gives the person handling the student a time line showing how long this has been a problem.

Finally, you will want to recommend a course of action for the discipline personnel; again, whether your form asks for it or not. You should know the student best and what is appropriate as a consequence for a behavior. I had a principal send a student back to me after I had sent the student to the principal's office. Upon seeing the student, I was flabbergasted and refused to let him into my classroom. The principal called and asked what I wanted done with the child and later requested that I indicate on the referral the consequence I wanted the office to follow up with so there would be no misunderstanding about the action that should be taken.

A copy of the referral is your best documentation of this type of incidence. Usually, the office will record the infraction and the consequence in the student's file in the computer and then return the referral to you. File the referral in a discipline file in your desk drawer; hopefully, the problem will have been solved.

If you must write a second referral on a student for the same infraction, it is time to call the parents for a meeting about a new strategy for helping the student.

BEHAVIORAL PLANS

If a student persistently exhibits problem behavior in class, with no signs of improvement after you have tried other consequences, it is time to put the child on a behavioral plan.

A behavioral plan maps out for a student the offending behaviors that are occurring, the positive behaviors that are desired, and what the rewards will be for those positive behaviors. It is important to invest the time to create a behavioral plan for a student with consistently poor behavioral choices, because the structure of the plan often creates an atmosphere in which the student can be successful.

The first thing you will want to do is investigate whether the child has shown these behaviors before and how they were dealt with in the past. You will want to interview the parents and previous teachers. Asking these stakeholders if the behavior had been exhibited elsewhere and how it was handled in the past will not only validate your observations, but could give you strategies that have worked in the past.

If interviewing parents and teachers doesn't offer a strategy that has worked in the past, you will want to contact your school psychologist or counselor. Explaining the situation to this professional may shed some light on things you could be doing differently in the class.

Once you have gathered information from people who know the student well, you will want to pay close attention in class to when the student exhibits the inappropriate behaviors. Does the behavior always

Stakeholder Interview

Person interviewed:

Description of recurring behavior:

Strategy used to diminish behavior:

occur during reading time, or when children are moving about the class? You will want to record this information as a guide to what classroom situations need to be closely monitored once the plan is in effect.

Student Observation

Date:

Person observing:

Time:

Class activity:

Behavior:

If possible, it is a good idea not only to record your observations, but to have a third party come into your class to observe. Having a third party present relieves you of accusations of being biased and also allows you the opportunity to see your behaviors in response to the behaviors in a new light.

Once you have gathered all of this information, write a behavioral plan. The plan needs to begin by addressing the student's strengths and the times when the student acts appropriately. The focus of the plan will be on helping the student successfully expand those times to include the entire classroom experience.

Defining the times when the student behaves inappropriately, then outlining intervention strategies, some to be implemented by the teacher

and some to be implemented by the student, helps both student and teacher feel that the situation is controllable.

It is important to clearly state how a student can earn more privileges in the classroom, and what the consequences will be for acting inappropriately. A behavior plan should have these elements:

Behavioral Plan for: _____

Goals: _____

Interventions: _____

Person responsible: _____

Rewards: _____

Consequences: _____

Once you have drafted this document, remember that it is a work in progress. The first person you will want to consult with is your site counselor or administrator in charge of discipline. You will want another opinion on the wording you used to be sure it is appropriate.

Once the wording is deemed appropriate, you will need to set up an appointment with the parents and the student. Be prepared to revise the plan once you have the parents' input. The plan needs to be something that everyone supports.

A sample plan could look like this:

Behavioral Plan for: *Sarah Student*

Goals: to remain focused on activity for duration of class

Intervention: 1. Verbal reminders and seating change. 2. Recording verbal reminders at top of work

Person responsible: 1. Teacher. 2. Student

Rewards: Choice of seat in class, preferred activity time, homework ticket

Consequences: Time-out, loss of privileges, detentions, referral

This plan is relatively simple and easy to follow. It is a good place to start, especially if you are unfamiliar with implementing behavioral plans. As you become more experienced with behavioral plans, your ability to use this course of action to resolve unwanted behaviors in your class will increase.

CONCLUSION

Managing children well is a talent acquired with experience. One of the best ways to hone your skills in handling difficult students is to record the actions you take with these students. Keeping good records removes the sense of "good guy" versus "bad guy" and moves the discussion to appropriate behaviors and problem solving. If you diligently keep records of your attempts to manage your students more effectively, you will find that support personnel, parents, and administrators are more willing to support you in your efforts.

Your classroom management records can often show you when a student needs more attention. Accommodations and modifications may be necessary to ensure a student's success.

4

Parent Contact Records

Diane had been a borderline A student all year, so when, in the last few months of the school year, her grade dropped to a C, I thought little of it. I didn't contact the parents, because she wasn't failing and I had to alert them only if Diane was in jeopardy of failing. I did have several discussions with Diane about how her grade had dropped, believing that she was the person responsible.

I turned in my final grades and headed out for summer vacation, only to receive a phone call two weeks into it from my principal. Diane's parents had called and were livid. Could I come in to put out the fire? I dutifully called the parents and set up an appointment with them.

On the day I was to meet with them, I arrived at school early so I could gather my grades and any work I had of Diane's, except I had just cleared out for summer and had readied my classroom for the following year. I had little to offer the parents except a grade printout.

As you can imagine, the meeting did not go well. I explained that I had discussed Diane's grade with her several times and was not legally required to contact parents unless Diane was failing. They wanted to know if I was morally responsible for contacting them, since they were legally responsible for Diane. That one stuck.

They left owning the fact that Diane failed to communicate with them about her slipping grade, and I left accepting the fact that just because I was not legally required to contact the parents, I was morally responsible for keeping them informed of what was happening with their daughter.

Keeping parents involved in their child's education results in "enhanced student achievement" (Ryan, 2003, p. 167). Involving parents should extend past the traditional Back-to-School night and Open House, beyond the traditional parent-teacher conferences. Parents should be involved in the daily management of schoolwork and supplies and teacher-student interactions if necessary. Being proactive in involving parents will often prevent problems, enhance already good relationships, and make your job of teaching their children much easier.

Keeping records of each time you contact a parent will allow you to be better prepared for every meeting you have with parents. Imagine if I had been able to meet Diane's parents with a list of phone contacts and copies of letters I had sent home informing them of curricular requirements and important due dates. If I had had all those documents, there probably would have been no need for the meeting.

These records will

- Keep track of your communication with parents
- Inform your discussions with parents
- Prepare you to answer questions, find solutions, and support parents in the ongoing process of a child's success in school

LETTERS HOME

To keep track of your letters home, you can create a file labeled something like "Parent Letters" to keep in your desk's file drawer. In this file, you will want to place copies of any and all letters you send home. You should also save copies of these correspondences on your computer, but if you need to show up at a meeting, it is easier to pull a copy from your file drawer than it is to print a copy from your computer.

The other organizing paper you will want in the drawer is a copy of the spreadsheet with student names. This makes a very easy reference guide for which letters were sent home and to whom.

Student Names	Letter Home	Tutoring Reminder	Thanks Back-to-School Night									
Don Arias	All		All									
Chris Black	/	X	/									
Tonya Cuera	/		/									
Wesley Dorn	/	X	/									
Etc.												

On the spreadsheet, you can note the topic of the letter sent home and mark which students' parents received a letter. If you send a letter to every parent, you can simply write "all" at the top and draw a line. Other letters might be sent to certain parents regarding specific issues. The spreadsheet allows you to keep all of this clear.

Your first letter home will be your traditional "Welcome to my classroom" letter. You will obviously send this home to all of your students and their parents. Many teachers include in their letters a place for parents to sign before returning the letter to the teacher, indicating that the parent and student have read and understood the classroom policies. You can check off on your spreadsheet which parents and students returned this document signed, and retry with those who didn't. Mailing the second copy rather than sending it home with the student is a good idea.

Other types of letters you may send home over the course of a term are reminders about tutoring for students who are struggling, thank-you letters to parents who volunteer help with school activities, good news letters for parents of students who are doing well, and other documents relating important information about your class. Having a record of which letters you have sent home and to whom makes you better prepared for parent conferences and indicates to parents that you are interested in keeping them involved in their children's education.

Many teachers have the opportunity to e-mail parents with information. I suggest printing a copy of the e-mail and placing it in your file, and saving a copy into a file on your computer. It is probably also a good idea to make a notation of the correspondence on the spreadsheet.

An easy way to keep parents involved in their children's education is by keeping them informed through letters home. Keeping records of these correspondences better prepares you to handle all parents and their children.

PHONE CALLS

Returning phone calls or making phone calls to parents is one of the easiest ways to make direct contact, whether it is over a concern or a success. Keeping track of phone calls is important to your record keeping because one of the most common complaints from parents is that teachers fail to return their phone calls.

Most districts and principals have a 24-hour rule: If a parent calls you, you need to return the call within 24 hours. Sometimes this is easier said than done with parents' busy schedules. Several years ago I was in the faculty lounge, returning a phone call to a parent. I got the answering machine and dutifully left a message about a student's failure to complete a project. Upon hanging up, I heard my principal's voice behind me.

"The kid's going to erase that message."

"Maybe, at least I left one."

He laughed. Lo and behold, the mother showed up in my class the next day, angry because I hadn't called her back. When I asked her if she had

gotten my message, she immediately looked at her son, who gave himself away by the look on his face. The point is, I was responsible for returning the call and trusted that the mother would get the message. Everything worked out fine in the end.

Being responsible about returning phone calls is not just a matter of returning them, but also of recording when you returned the call and with what result. You may speak to several parents over the course of a week and therefore forget to whom you talked and about what. A parent, on the other hand, probably rarely speaks to a teacher and so will have a clear memory about the conversation and when it took place.

There are several ways to keep track of phone conversations you have with parents, and I suggest keeping a paper trail of these communications.

First, if the parent initiates the call, you will have received a message in your box with the parent's name and phone number. This is an important document to keep for future reference. First, it indicates whether the message was taken down correctly. There is nothing worse than being accused of making a mistake that was actually someone else's. Second, it gives you a good place to record failed attempts to get hold of the parent. If you call and receive a busy signal or it simply rings forever, then the responsibility for the communication is still in your court and the message slip should still be on your desk to remind you to call. In keeping with the 24-hour rule, you will want to record the date and time of your attempt even though you know you will need to try again.

Most school districts provide teachers with a phone log that looks similar to this:

Student	Contact Person	Date/Time	Comments

You wouldn't need to write down all of your attempts here, although you could. Instead, each time you contact a person, or an answering machine, you would write down the details for future reference.

I prefer another method. Each year I use my spreadsheet program to create a form that looks similar to my grade sheets but has only one section—for recording my phone contacts with parents.

Students	Date, Topic
Don Arias	9/12 no homework, spoke to mom. 10/12, returned call about absences and make-up work
Chris Black	10/13, called about missed detention, left message with brother
Tonya Cuera	
Wesley Dorn	12/3 called about passing notes, spoke to grandma
Etc.	

This format allows me to see at once how many times I have called a particular student's home and about what topics. When I'm speaking to someone on the phone, I can refer back to the last time we spoke, especially if the call is about a recurring problem.

My colleague, Cyndi, uses a Voice Mail Log Book. The inside of the book allows her to record the date, time, caller, phone number called, and message or result. You can find one of these books at any office supply store. It's easy to open the book and begin recording the information while you wait for someone to answer the phone.

Whether you use a contact-driven log or a student-organized one, the important thing is to keep track of your home contacts so you are better prepared to speak with parents.

WHOLE-GROUP CONTACTS

Some of your communication with parents will be attempts to contact all of your students' parents. Things like the previously mentioned "Welcome to class" letters will be recorded elsewhere, but it is important to record other whole-group contacts like Back-to-School Night and Open House presentations, other presentations through school such as GATE (Gifted And Talented Education) meetings, and automated phone calls.

The easiest way to record attendance at your presentations to groups of parents is to have the parents sign in. The sign-in sheet should ask for pertinent information and invite parents to request a more personal contact if they wish.

Back-to-School Night

Name: _____ Child: _____ Contact Number: _____
Request for Conference: _____

1. _____

2. _____

3. _____

This type of form can be used for any presentation by simply changing the title. The list is a handy reminder of which parents routinely attend the presentations. It allows you to be prepared to speak about the ideas presented to a large group when meeting with individual parents who attended the presentation, and it provides you and your school with a document recording attendance to these presentations.

PERSONAL CONTACTS

Whenever you meet personally with a parent, it is important to keep clear records of what occurred, whether the meeting was part of a formal conference, or an informal discussion you had at the book fair, the grocery store, or out by the busses.

Parent-teacher conferences are important events for parents and students. Because you attend so many of these meetings, it could be easy for you to take them in stride, feeling there is no need to record what occurred. Likewise, there will be many conferences where someone else may be taking notes, the counselor or support teacher, and you may feel there is no need for you to take down what occurred.

It is important for you to keep a record of what occurred at any parent-teacher meeting for your records. Remember, although you attend several of these meetings each month, parents rarely meet one-on-one with their child's teacher. It is a big event for a parent and must be handled accordingly by you.

Parent-Teacher Conference Date: _____

Who attended:

Topics of concern:

Parent suggestions:

Teacher suggestions:

Agreed course of action:

Showing up at the conference with this paperwork to fill out will not only keep you and the parents focused on solving any problem, but will send a clear message to the parents that you are taking the meeting seriously. Also, writing down an agreed-upon course of action generally keeps all parties involved committed to fulfilling the agreement. After the meeting, you can file this paperwork in a file for the student or in a general file for conferences.

The other interactions you will have with parents include informal discussions that occur when you run into them at school events or community events or while you are out shopping.

If you are a new teacher, it is probably a good idea to avoid discussing school situations with parents in these informal settings. Away from your professional surroundings and without your paperwork in front of you, it will be easier for parents to manipulate the conversation, especially if it is a topic they are passionate about: their child. If a parent approaches you, politely ask him or her to make an appointment to meet with you after school. Explain that you would be better prepared to discuss the situation at that time.

If you feel comfortable discussing students or situations with parents informally, it is still important that you write down what you discussed as soon as possible, while it is still fresh in your mind. That may mean that you jot down some notes on the back of a receipt or on an old envelope.

You will want to write down who you talked to, what you talked about, and whether you should contact the person once you are back at school. Once you are back at school, transfer this information to a form like the one above, noting that the meeting was informal, and then follow up or file away. If a parent approaches you later about something he or she believes you said in a conversation at the soccer field, you can bring up your records to remind yourself of what happened.

PROGRESS REPORTS

Keeping parents updated on how their child is progressing is vital to a good relationship between school and home. Most school districts have a system for informing parents of a student's progress halfway through the term and then, of course, at the end of the term: report cards. The school provides you with an official form to report on each child's progress toward meeting the grade-level standards. These forms are either mailed home or sent home with the students.

In our school district, we legally have to report to a parent only if a child is in jeopardy of failing a course. As I learned with Diane, the student who earned a C when her parents believed she was an A student, it is important to let all parents know how their children are progressing, whether they are high achievers or struggling students.

Reporting on student progress halfway through the term is, of course, a good idea and, given all of the demands on a teacher's time, may be all you can keep up with, but there are ways to keep your students' parents

informed of curricular progress beyond sending official forms home. Giving students a weekly progress report that they fill out and take home on Fridays for their parent's signature gives the responsibility of communicating with parents to students.

Name: _____ Week: _____

Dates absent: _____

Received and completed makeup work: _____

Homework completed and turned in: _____

Last week's quiz score: _____

Important due dates: _____

Collecting last week's progress report on Mondays and handing out this week's progress report on Mondays keeps everyone focused on staying current with the work and with being sure everyone is involved in keeping track of a student's progress, including the student.

Many teachers create a progress report for students that they fill out for them on Fridays.

Student: _____

All class work turned in: _____

Missing assignments: _____

Behavior: _____ good _____ needs improvement

Grade to date: _____

This requires good organization; many teachers are able to keep up with reporting to parents in this manner. Some teachers choose to send this type of report only to parents of students who are struggling, while others report on a different group of students each week, cycling through all the students each quarter.

Of course, if you have the resources, the easiest way to report regularly is to print out the spreadsheet grades on your computer. Since you regularly input student grades into the computer, all you need to do is to print out each child's spreadsheet. Grading software you can buy makes this very easy to do, but you must have the paper and printer ink to be able to do this regularly.

In any of these cases, you will want to keep track of when you sent progress reports home to parents. If you print out grade sheets or hand out reports to all students, simply noting in your lesson plan book the day you sent these home is sufficient. If you "cycle through" your students, you obviously have a system to keep track of your cycle that keeps track of who got reports when. This information is very valuable when you need to meet with a parent regarding a student's progress.

CONCLUSION

It is easy for us to become so involved with our day-to-day schedule that finding time to communicate with parents becomes a last-resort activity for the child who is failing or disruptive. As professionals, we must make communicating with parents regularly throughout the school year a top priority.

Keeping records of your parental contacts helps you to keep track of your communication with parents, which in turns informs all your discussions with them. You will be better prepared to answer questions, find solutions, and support parents in their efforts to ensure their children's success.

Parental contacts are one of your many means of managing your students for success in your classroom. Your management of classroom records will ensure students' success.

5

Special Needs and Accommodation Records

As a good teacher, you will naturally be making accommodations for your students, whether they are specified as part of Gifted And Talented Education (GATE) or are struggling. But, you will have a special population who require specific accommodations according to their 504 plan or their individual education plan (IEP). It is important for these students that you create records to account for all of the modifications you are making in the classroom to accommodate all of your students' needs.

Many of the records you are already keeping will provide you with ample evidence of the accommodations you are making. Logs of special instructional time, records of modifications and accommodations, and justification for failing grades all provide you with evidence of specialized instruction geared to meet the needs of your students. Seating charts, notes on grading rubrics, highlighted grades, and parent or student contacts help support these records. The records in this chapter will help you

- Organize records into stakeholder-friendly formats
- Organize the accommodations and modifications you use
- Prepare you and others to make adjustments to meet needs of students

SPECIAL INSTRUCTIONAL TIME LOGS

To keep track of when students leave your classroom for outside support—whether from a special education teacher, a speech teacher, a language teacher, or other support personnel—you will need records. Since students

will often leave during instructional time, having a sign-out/sign-in log for them to use when they leave the class takes the burden off of you and places it on the student. The log could look like this:

Sign-Out Sheet

Name: _____ Date: _____ Time: _____

Destination: _____ Return time: _____

1.

2.

3.

etc.

Place the log by the door so students will have easy access to it when leaving or entering the class. You will want to check it periodically for accuracy and to file the information in your records. If you have younger students, you may need to spend a few minutes at the end of each day adding information such as last names or the reason for the extra help.

INTERVENTION LISTS

Another important record is an interventions document that clearly records when you have used interventions to support a student in being successful in your classroom. It could look like this:

Interventions

Student Name: _____

1. Adjust seating arrangement Dates: _____

2. Adjust teacher expectations of performance level Dates: _____

3. Reduce incoming stimulation Dates: _____

 a. Isolation from group and/or noise stimulation Dates: _____

 b. Time-out Dates: _____

 c. Study carrels Dates: _____

(Continued)

4. Positively reinforce positive behavior Dates: _____

5. Loss of privileges Dates: _____

6. Communication with parents Dates: _____

7. Visual chart that encourages self-monitoring Dates: _____

8. Daily/weekly progress report home Dates: _____

9. Individual time with teacher, aide, or volunteer Dates: _____

10. Shorter assignments Dates: _____

11. Change in level of assignments Dates: _____

12. Directions (vary approach, clarity with concrete Dates: _____
 instructions)

13. Use of concrete teaching devices (manipulatives) Dates: _____

14. Provide immediate and frequent knowledge Dates: _____
 of results

15. Use of high interest/low vocabulary materials Dates: _____

16. Cross-age or peer tutoring or buddy system Dates: _____

17. Vary learning modality Dates: _____

18. Make sure that any behavioral consequence is due to
 behavioral problems rather than learning difficulties

You may have other interventions you are using with your students who are struggling. Most of these interventions are recorded elsewhere, whether in the seating chart or on student assignments collected in students' folders or portfolios, but taking the time to fill out this intervention list clarifies for parents, other support personnel, and your administration what you have been doing in the classroom to accommodate any special needs students you have.

ACCOMMODATION DOCUMENTS

Another pertinent record to keep for students who have an IEP, 504 plan, or other legal document requiring that special accommodations be made in the classroom are the specific accommodations being made as required. Usually you will be provided with a copy of the report, which will indicate to you which accommodations must be made. At that point, it is a good idea to create an accommodations list to fill out throughout the year to be sure you are following the special requirements for the student.

Accommodations List

Student: _____ Grade: _____

Dates: _____ Special concerns: _____

Modifications

_____ Cooperative grouping

_____ Oral responses to assignments [tape recording or with adult]

_____ Use of advance organizers

_____ Computer assistance

_____ Directions read or prerecorded

_____ Directions highlighted or repeated

_____ Test read to student

_____ Modified assignment or assessment

_____ Extended time

_____ Picture prompts

_____ Preferential seating

_____ Peer support

_____ Pull-out help

As with the interventions list, this record allows you to take information from other records you are keeping on a student and assemble it in a single document for easy access and for sharing with stakeholders. You may need to adjust this list to reflect the special needs of your students.

GRADE JUSTIFICATION SHEET

Finally, if you have implemented and recorded all of the interventions and the modifications in place for the student, and the student still is unable to reach the goals of the IEP, or if a stakeholder doesn't agree with the grade earned, it is important that you create a grade justification sheet.

This form records all the modifications and accommodations you have put in place to help the student be successful in your class. It also helps to inform all stakeholders of other accommodations that may be added or modified for future success of the student.

Justification of Grade

Name: _____

School/Grade: _____

Subject: _____

Modifications provided by the regular classroom teacher:

Supports and services provided by special education staff:

Student response to staff efforts:

Reason for failing grade, despite modifications, supports, and services:

A student with an IEP has a case manager, someone in charge of making sure that all the accommodations are being made for the student. For students with 504 plans, however, the classroom teacher is responsible for making sure the accommodations are being made for the student. It is extremely important that the records you keep in this area be consistent and thorough.

CONCLUSION

Many of the records you are already keeping show the interventions and modifications you are using to help support all students in your class. The documents in this chapter will help you to organize these records in a stakeholder-friendly manner to ensure that everyone understands the professional job you are doing with this special population.

Finally, these records and others you have kept will be organized from time to time to present at meetings with others.

6

Using Your Records When Meeting With Students, Parents, or Administrators

It is the end of the day and it has been a long one. Not only is it Monday, but there was a routine fire drill during which Francisco decided to wander away from line and Sherry and Billy decided to push each other. There was the incident with the lunch money that Mena thought was stolen but was found in her backpack: "My mom never puts my money there." And there was the lunch meeting with your grade level to go over testing for next week.

Your feet are tired and your throat is a bit sore and you still have a meeting this afternoon. Whether the meeting at the end of your long day is with a student, another teacher, your administrator, or parents, no matter how long your day has been, it is important for you to be prepared, professional, and perky. Your energy level must be high for this meeting, and worrying over how to make your point of view clear or trying to recall

what information is pertinent to the meeting or leaving for the meeting with nothing in hand can all drain your energy and make the meeting seem interminable.

Keeping the records recommended in this book will make your meetings easier and extend your professionalism, help you to troubleshoot situations, and encourage you to be self-reflective in your practices. Not only that, but the records will impress your students, your colleagues, your students' parents, and your administrators.

Now all you have to do when faced with a meeting is gather your records and show up prepared, and with no trepidation about how the meeting will turn out. The documents in this chapter will help you do the following:

- Keep records accessible for unexpected meetings
- Gather and organize records to meet the needs of a meeting
- Prepare records for presentation at meetings

STUDENT MEETINGS

Students have a right to see the records you are keeping on them. Actually, this works in your favor because it takes away the sense that the teacher has the power to make or break a student through personal bias. We've all heard the "teacher's pet" comments that imply that students you like are favored when it comes to grades. The easiest way to dispel these notions is to provide every student with updated grade and citizenship records on a regular basis.

Generally, a student will approach you at an inappropriate time. It is important to teach students the proper way to set up an appointment with you to review your records of their progress. Resist the urge to ignore the rest of the class for a few moments to show a student a grade. If you do not have time set aside in your day for personal conferences, you must simply request that the student meet with you during a break, after school, or at another appropriate time. Meeting with the student during time that you can devote exclusively to the student will ensure that you are able to give the student your undivided attention and that the student has an opportunity to ask any clarifying questions he or she may have.

The records you should have prepared for the student include a grade printout, any running records or notes you have taken on the student's progress, the student's file of work, and any discipline files you have kept on the student. Having all of these records in front of you when you meet with the student will force you and the student to focus on documents rather than on personalities.

Before sharing any records, ask the student what the concern is and then use only the records that address that concern. Pulling out all of the

student's time-out forms when the student is concerned about his score on the standardized test is applicable only if you are showing the student how he is missing valuable instruction time. Be clear about why you are presenting a record to a student.

After meeting with the student, it is important to document the meeting, including your impressions of how it went. Perhaps, if the student still is concerned, you might want to follow up with a phone call home to the parents. Students who leave a meeting dissatisfied will share that dissatisfaction at home. You want to be proactive about resolving the issue. Be the first to suggest a meeting with you, the student, and the parents all present.

PARENT MEETINGS

As has been mentioned several times in this book, when a parent meets with a teacher, it is an important event for the parent. As a teacher, you might conduct several parent-teacher conferences each week. On the other hand, the parent rarely meets with his or her child's teachers. Be sure to prepare carefully for this event so that you conduct yourself in a professional, caring manner.

There are several things you will want to do before attending a meeting with parents. You will, of course, want to collect all of your records on the student. Be sure you have the following:

- Grade printout
- Home contact records
- Discipline records
- Accommodation records
- Student file, which includes sample work, rubrics, and running records

The second step is to be sure what the focus of the meeting will be. There are two types of meetings. One is a routine parent-teacher conference during which you will share your data on how well the student is progressing through the curriculum. The other is a problem-solving meeting during which you and the parents and perhaps other support personnel will be trying to help a student be more successful. These two meeting types require different preparation.

For the routine parent-teacher conference, the expectation is that you will give a progress report. You will want to prepare to give parents the best overall impression of how their child is progressing in your class. There are several areas that you will want to prepare to report on: progress, strengths, areas for improvement, and citizenship. After pulling all the records mentioned previously, you will want to record your impressions on a form that looks like this:

Student: _____ Class: _____

Date of conference: _____

Strengths: _____

Areas of needed improvement: _____

Recommendations for home support: _____

Teacher's plan for future: _____

Grade to date: _____

Citizenship: _____

When you fill out this form, be sure that you pull pertinent records—like grading rubrics—that illustrate a student's strengths or weaknesses. You may also use sample work and running records. You will want to discuss behavioral issues only if you feel that the parent can support you. If there have been behavioral issues, it is better to have addressed them before this routine meeting rather than waiting until now.

You will discuss citizenship, as that is part of your evaluation of the student. Be sure your remarks relate to the type of student the child reveals himself or herself to be. Indicating when the student is most on task or when the student seems most interested in class will help both you and the parents adjust the curricular focus to meet the needs of the student.

You will want to have suggestions for parents on how they can best support their child in school. These may be as simple as reinforcing a regular homework time or, for an overachieving student, suggesting some outside reading the student may be interested in. By making these suggestions, you reinforce the idea that learning continues at home and that you and the parents are partners in supporting the child's education.

You might also want to share some ideas you have for extended in-class support that you will provide. If you are going to ask parents to make an extra effort with their child, you need to be willing to do the same. Your support may be something you do regularly with your students anyway,

but mentioning it to parents lets them know that you are thoughtful about how best to engage their child.

Remember, it is not fair bring up major concerns at a regularly scheduled conference. The parents will feel that you have blindsided them. They have come to the meeting expecting a progress report, but you have dumped a problem in their laps. If there is a problem, whether it is social, academic, or behavioral, you must contact the parents outside of the regularly scheduled conferences to deal with the situation. Waiting until the regular parent-teacher conference will make it appear that you were reluctant to solve the problem or too busy for their child's needs.

If the conference has been scheduled to discuss a concern, whether on the part of the parents or on your part, then preparation for the meeting will be different. You will want to be clear about the situation to be addressed and collect the records that address the concern. If the problem is academic, you will want to be prepared with records that show the student's academic achievement and with comparison records from either another student working at grade level (with the name removed) or from the state-prepared documents that set out state standards.

Student: _____

Date of conference: _____

People in attendance: _____

Student work: _____

Comparable work: _____

Suggestions: _____

Be sure to approach the meeting with an open mind about the plan of action. At this point, you are informing parents and working with them on how best to support their child in school. Once you have decided on a course of action for supporting the child, be sure to document it, send a copy home to the parents, and file your copy for future reference. If the problem persists, you have documentation that you and the parents have tried to resolve the situation within the classroom and now require outside help, whether from the school counselor or psychologist or some other support personnel.

If the problem is behavioral, you will want to have records not only of the student's misbehaving, but also of the actions you have already taken to try to resolve the problem. Remember, do not wait until the problem is so big that you do not have any more ideas about what to do. Refer back to Chapter 4, and be sure to follow the procedures and record keeping there, including phone calls home and detentions. By the time you meet with the parents, you should already have been in communication with them regarding the situation and already have some problem-solving techniques in place. This meeting will most likely be for a behavioral support plan to be agreed upon and signed by you and the parents.

On the other hand, the parents may have called the meeting because of a behavior they think you are exhibiting that they disagree with.

My classroom policy is that all failing students sit in the front of the classroom. I counsel individual students privately about how they can get their seat changed when they ask me why they have to sit up front. I had a student who questioned her seat every day with the entire class as her audience.

"Can't I have a new seat?" Britney would ask.

Finally, even other students were asking me whether or not Britney could have a new seat. I calmly explained that Britney knew how to get herself a new seat, explaining that as long as I felt Britney needed extra help, she would be up front.

Mom asked for a conference with me, then lambasted me for embarrassing Britney in front of her peers by indicating that Britney needed extra help. I had all my records of phone contacts and the extra help provided and all of Britney's tardies and absences, but knew right away that I was not going to win the argument. Despite all I had done, this mother was convinced I was in the wrong. I offered to move Britney's seat despite my policy, the mother relented and indicated she wanted Britney to receive extra help, and the conference ended on a less-than-cordial note.

Sometimes, even having all of your records is not going to resolve the situation. Britney failed my class despite my best efforts to support her. You will also have some children who fail, but you will rest easier knowing you did all you could professionally to help all of your students.

ADMINISTRATOR MEETINGS

If your administrator asks to meet with you, it is probably regarding something minor or routine, such as your annual evaluation. Still, there is nothing as unsettling as being asked to meet with your administrator but not knowing why.

When asked to meet with your administrator, you will want to find out the purpose of the meeting so you can prepare. If the secretary is setting up the meeting and he does not know the reason for it, ask him to find out and give you a call. Once you know the agenda for the meeting, you can prepare.

If the meeting is regarding your evaluation, prepare by bring your lesson plan book and calendar. The administrator will want to set up times to visit your classroom, and you will want to be able to let her know when the best times to visit are. Having your lesson plan book will allow you to see at a glance whether you will be conducting oral presentations or having silent reading on any given day. Obviously, silent reading is important, but it is not what your administrator wants to observe. Having your calendar with you will help you avoid double booking. Perhaps you must be absent from the classroom for district business or personal business. Your calendar will help you avoid scheduling conflicts.

Any other type of meeting will require you to bring specific records, depending on the topic. Before the meeting, you might want to ask which documents the administrator thinks will be pertinent. If you are unclear about the purpose of the meeting even after asking, be sure to bring your grade book, lesson book, and a notebook for taking notes.

Carrying these books will make you feel better prepared and give you more confidence during the meeting. Taking notes during the meeting is a good idea and gives you a record for future reference.

If you attend a meeting with an administrator and you feel attacked, excuse yourself from the meeting, explaining that you were unaware of the topic of the meeting and feel unprepared. Then reschedule the meeting and bring along all the records you need and a union representative to sit with you during the meeting.

CONCLUSION

Your records serve as documentation of the professional job you are doing and convince others of your lack of bias, your attention to detail, and your desire to keep all stakeholders informed. Knowing the type of meeting you are attending, which records are pertinent to the discussion, and having those records organized will not only make a meeting run more smoothly, but will often help you to avoid future meetings on the same topic.

Resources

Format for Syllabus

Key standards to be covered:

* _____

* _____

* _____

Standards to be reviewed:

* _____

* _____

* _____

Textbook(s): _____

Unit title: _____

Dates: _____

Objectives (Students will . . .):

1. _____

2. _____

3. _____

4. _____

5. _____

(Continued)

Assessments: _____

Projects: _____

Worksheets: _____

Key readings, outside readings: _____

Lesson Plan

Date: _____ Course: _____

Unit of study: _____

Set or sponge activity: _____

Review of homework: _____

Standard: _____

Objective: _____

Instruction: _____

Pages in textbook: _____

Guided practice: _____

Independent practice or homework: _____

Closure: _____

Assessment to be used at end of unit: _____

Lesson Plan for Veteran Teacher

Standard: _____

Objective: _____

Sponge: _____

Instruction/Pages of textbook: _____

Activity: _____

Homework: _____

Assignment Sheet

Monday: Textbook needed: Pages:

Title of assignment:

Directions:

Tuesday: Textbook needed: Pages:

Title of assignment:

Directions:

Wednesday: Textbook needed: Pages:

Title of assignment:

Directions:

Thursday: Textbook needed: Pages:

Title of assignment:

Directions:

Friday: Textbook needed: Pages:

Title of assignment:

Directions:

Directions for Project

Objective: What is to be accomplished?

Materials:

Method: Steps to accomplishment

 1.

 2.

 3. etc.

Special considerations:

Due date:

Substitute Teacher Plans

Introduction (Logistics of the classroom):

Daily schedule:

Materials:

Teacher's role in lesson:

Student's role in lesson:

Closure:

Grade Spreadsheet

Student Names														
Don Arias														
Chris Black														
Tonya Cuera														
Wesley Dorn														
Etc.														

Homework Document

Homework for week of: _____

Monday:

Tuesday:

Wednesday:

Thursday:

Friday:

Grade Sheet for Homework

Student Names	Week One	Week Two	Week Three	Week Four	Week Five	Week Six	Week Seven	Week Eight	Week Nine	Week Ten	Etc.			
Don Arias														
Chris Black														
Tonya Cuera														
Wesley Dorn														
Etc.														

Independent Study Sheet

Student name: _____

Class: _____ Teacher: _____

Dates to be missed: _____

Objectives: _____

Materials: _____

Assignments: _____

Method of evaluation: _____

Student signature: _____

Teacher signature: _____

Parent signature: _____

Assignments will *not* be accepted after _____

Make-up Work Documentation

Name: _____ Date(s) absent: _____

Assignments for your absence are attached or listed below. Notes are attached that you must copy and return. These assignments are due _____ days from now, on _____.

Log of Received Make-up Work

Name: _____ Date returned: _____ Assignments received: _____

1. _____

2. _____

Incomplete Work Notice

Dear: _____ (parent or guardian),

The attached work has been turned in incomplete. I wanted to bring this to your attention as incomplete work could jeopardize your child's ability to meet the requirements of the curricular standards. The grade for this assignment will not be recorded without your signature.

Thank you,

(Teacher)

Parent signature and date

Participation Slip

Name: _____ Date: _____

Topic: _____

My participation: _____

Running Record Sheet

Date: _____ Activity: _____

Student: _____

Notes: _____

Portfolio Reflection Sheet

Assignment: _____

Grade earned: _____

Describe the procedure for completing this assignment: _____

Describe the result of your effort: _____

What are you most proud of on this assignment? _____

If you could do it over, what would you change and why? _____

Portfolio Summary Sheet

Name: _____

Pretest score: _____ Posttest score: _____ Improvement: _____

First essay score: _____ Last essay score: _____ Improvement: _____

How I improved on tests:

How I improved in my writing:

What I still need to focus on:

What strengths I can build on:

Phone Log			
Student	*Contact Person*	*Date/Time*	*Comments*

Presentation Sign-In

Back-to-School Night

Name: _____ Child: _____

Contact Number: _____ Request for Conference: _____

1. _____

2. _____

3. _____

Parent-Teacher Behavioral
Concern Conference Documentation

Parent-Teacher Conference: Date: _____

Who attended:

Topics of concern:

Parent suggestions:

Teacher suggestions:

Agreed course of action:

Progress Report

Name: _____ Week: _____

Dates absent: _____

Received and completed makeup work: _____

Homework completed and turned in: _____

Last week's quiz score: _____

Important due dates: _____

Teacher-Generated Progress Report

Student: _____

All class work turned in: _____

Missing assignments: _____

Behavior: _____ Good _____ Needs improvement

Grade to date: _____

Off-Task Student-Generated
Paperwork Documentation

Name: _____ Date: _____

Paper returned: _____

Reason it was collected by teacher: _____

Time-Out

Name: _____ Date: _____

Go to Room #: _____

Assignment: _____

Return to class at: _____

Detention Slip

Date: _____

_____ has been assigned a detention for the following infraction:

_____ Classroom disturbance _____ Failure to bring materials to class

_____ Excessive tardiness _____ Inappropriate physical contact

_____ Verbal threats or _____ Other:
profanity

The student is to report to Room _____ at _____. Detention will last for thirty minutes and will be spent working on _____.

Parent signature: _____

Detention Reminder

Detention assigned to _____ on _____
for _____.

Discipline Referral

Student's name: _____ Class: _____

Place of incident: _____ Time: _____

Teacher: _____

Reason for referral: _____

Details: _____

Actions taken prior to referral: _____

Comments: _____

Interview Documentation

Stakeholder Interview

Person interviewed:

Description of recurring behavior:

Strategy used to diminish behavior:

Student Observation Documentation

Student Observations

Date:

Person observing:

Time:

Class activity:

Behavior:

Behavioral Plan

Behavioral Plan for: _____

Goals: _____

Interventions: _____

Person responsible: _____

Rewards: _____

Consequences: _____

Sign-Out Sheet

Name: _____ Date: _____ Time: _____

Destination: _____ Return time: _____

1.

2.

3.

Etc.

Interventions List

Interventions

Student name: _____

1. Adjust seating arrangement	Dates: _____
2. Adjust teacher expectations of performance level	Dates: _____
3. Reduce incoming stimulation	Dates: _____
a. Isolation from group and/or noise stimulation	Dates: _____
b. Time-out	Dates: _____
c. Study carrels	Dates: _____
4. Positively reinforce positive behavior	
5. Loss of privileges	Dates: _____
6. Communication with parents	Dates: _____
7. Visual chart that encourages self-monitoring	Dates: _____
8. Daily/weekly progress report home	Dates: _____
9. Individual time with teacher, aide, or volunteer	Dates: _____
10. Shorter assignments	Dates: _____
11. Change in level of assignments	Dates: _____
12. Directions (vary approach, clarity with concrete instructions)	Dates: _____

(Continued)

13. Use of concrete teaching devices (manipulatives) Dates: _____

14. Provide immediate and frequent knowledge Dates: _____
 of results

15. Use of high interest/low vocabulary materials Dates: _____

16. Cross age or peer tutoring or buddy system Dates: _____

17. Vary learning modality Dates: _____

18. Make sure that any behavioral consequence is due
 to behavioral problems rather than learning difficulties

Accommodations List

Student: _____ Grade: _____

Dates: _____ Special concerns: _____

Modifications

_____ Cooperative grouping

_____ Project-based outcomes

_____ Oral responses to assignments (tape recording or with adult)

_____ Use of advanced organizers

_____ Computer assistance

_____ Directions read or prerecorded

_____ Directions highlighted or repeated

_____ Test read to student

_____ Modified assignment or assessment

_____ Extended time

_____ Picture prompts

_____ Preferential seating

_____ Peer support

_____ Pull-out help

Parent-Teacher Conference Sheet

Student: _____ Class: _____

Date of conference: _____

Strengths: _____

Areas of needed improvement: _____

Recommendations for home support: _____

Teacher plan for future: _____

Grade to date: _____

Citizenship: _____

Academic Conference Sheet

Student: _____

Date of conference: _____

People in attendance: _____

Student work: _____

Comparable work: _____

Suggestions: _____

References

Arter, J. & McTighe, J. (2001) *Scoring rubrics in the classroom: Using performance criteria for assessing and improving student performance.* Thousand Oaks, CA: Corwin.

Benson, B. & Barnett, S. (1999) *Student-led conferencing using showcase portfolios.* Thousand Oaks, CA: Corwin.

Burke, L. M. (2002) *The teacher's ultimate planning guide: How to achieve a successful school year and thriving teaching career.* Thousand Oaks, CA: Corwin.

Johnson, J. (2002) *Introduction to the foundations of education.* Boston: Allyn & Bacon.

Jonson, K. F. (2002) *The new elementary teacher's handbook: Flourishing in your first year* (2nd ed.). Thousand Oaks, CA: Corwin.

Kottler, E. & K. J. A. & Kottler, C. J. (2004) *Secrets for secondary school teachers: How to succeed in your first year.* Thousand Oaks, CA: Corwin.

McCroskey, J. C., & McVetta, R. W. (1978). Classroom seating arrangements: Instructional communication theory versus student preferences, 27(2), 99-111.

Partin, R. C. (1995) *Classroom teacher's survival guide: Practical strategies, management techniques, and reproducibles for new and experienced teachers.* West Nyack, NY: The Center for Applied Research in Education.

Ryan, M. (2003) *Ask the teacher: A practitioner's guide to teaching and learning in the diverse classroom.* Boston: Allyn & Bacon.

Slavin, R. E. (2003) *Educational psychology theory and practice* (7th ed.). Boston: Allyn & Bacon.

Tate, M. L. (2003) *Worksheets don't grow dendrites: 20 instructional strategies that engage the brain.* Thousand Oaks, CA: Corwin.

Thompson, J. (2002) *First–year teacher's survival kit: Ready-to-use strategies, tools & activities for meeting the challenges of each school day.* Paramus, NJ: Center for Applied Research in Education.

Wyatt, R. L., III & White, J. E. (2002) *Making your first year a success: The secondary teacher's survival guide.* Thousand Oaks, CA: Corwin.

Zentall, S. & Goldstein, S. (1998). *Seven steps to homework success: A family guide for solving common homework problems.* FL: Specialty.

Index

**CORWIN
PRESS**

The Corwin Press logo—a raven striding across an open book—represents the union of courage and learning. Corwin Press is committed to improving education for all learners by publishing books and other professional development resources for those serving the field of K–12 education. By providing practical, hands-on materials, Corwin Press continues to carry out the promise of its motto: **"Helping Educators Do Their Work Better."**